Coming of Age

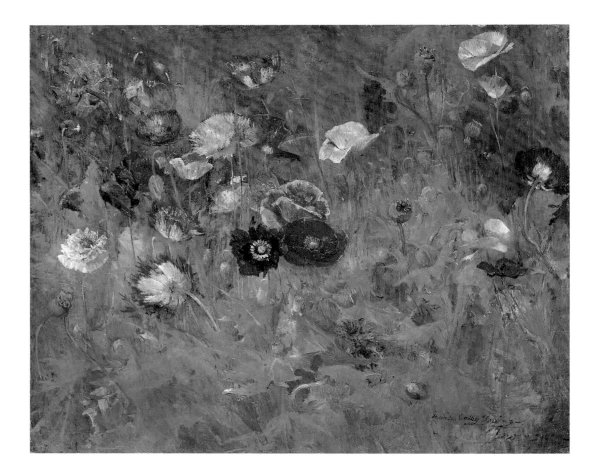

Coming of Age

American Art, 1850s to 1950s

WILLIAM C. AGEE AND SUSAN C. FAXON

AMERICAN FEDERATION OF ARTS IN ASSOCIATION WITH
YALE UNIVERSITY PRESS, NEW HAVEN AND LONDON

Published in conjunction with an exhibition organized by the American Federation of Arts
and the Addison Gallery of American Art, Phillips Academy, Andover, Massachusetts

This catalogue is published in conjunction with *Coming of Age: American Art, 1850s to 1950s*, an exhibition organized by the American Federation of Arts, New York, and the Addison Gallery of American Art, Phillips Academy, Andover, Massachusetts. The exhibition is made possible, in part, by The Crosby Kemper Foundation and by Frank B. Bennett and William D. Cohan, with additional support from the Philip and Janice Levin Foundation Fund for Collection-Based Exhibitions at the American Federation of Arts.

The AFA is a nonprofit institution that organizes art exhibitions for presentation in museums around the world, publishes exhibition catalogues, and develops education programs.

Guest Curators: William C. Agee and Susan C. Faxon

Publication Director: Michaelyn Mitchell
Managing Curator: Susan Ross
Design: Barbara Glauber and Emily Lessard, Heavy Meta
Editor: Stephanie Salomon
Indexer: Laura N. Ogar

"American Art, 1910–1950s: Themes, Traditions, Continuities,"
© William C. Agee.
"The Search for an American Expression, 1850–1917,"
© Addison Gallery of American Art.

Published in 2006 by the American Federation of Arts in association with Yale University Press, New Haven and London.

American Federation of Arts
305 East 47th Street, 10th Floor
New York, NY 10017
www.afaweb.org

Yale University Press
P.O. Box 209040
302 Temple Street
New Haven, CT 06520–9040
www.yalebooks.com

Front cover: Asher B. Durand, detail of *Study of a Wood Interior* (plate 5)
Frontispiece: Maria Oakey Dewing, *A Bed of Poppies*
Back cover: Frank Stella, detail of *East Broadway* (plate 46)

EXHIBITION DATES
Addison Gallery of American Art, Phillips Academy
Andover, Massachusetts
September 9, 2006—January 7, 2007

Meadows Museum of Art
Dallas, Texas
November 30, 2007—February 24, 2008

Dulwich Picture Gallery
London, England
March 14—June 8, 2008

Peggy Guggenheim Collection
Venice, Italy
June 28—October 12, 2008

Museum of Art, Fort Lauderdale
Nova Southeastern University
November 6–March 23, 2009

Musée national des beaux-arts du Québec
Quebec, Canada
May 21–September 7, 2009

Printed and bound in China
12 11 10 09 2 3 4 5

Library of Congress Cataloging-in-Publication Data

Agee, William C.
Coming of age : American art, 1850s to 1950s / William C. Agee and Susan C. Faxon.
 p. cm.
Published in conjunction with an exhibition at the Addison Gallery of American Art, Andover, Massachusetts, and at other venues beginning in 2006.
Includes bibliographical references and index.
ISBN 0-300-11523-7 (hardcover : alk. paper)
ISBN 1-885444-33-8 (softcover : alk. paper)
1. Art, American—19th century—Exhibitions. 2. Art, American—20th century—Exhibitions. 3. Art—Massachusetts—Andover—Exhibitions. 4. Addison Gallery of American Art—Exhibitions. I. Faxon, Susan C. II. Addison Gallery of American Art. III. Title.
 N6510.A44 2006
 709.73'0747445--dc22
 2006003137

CONTENTS

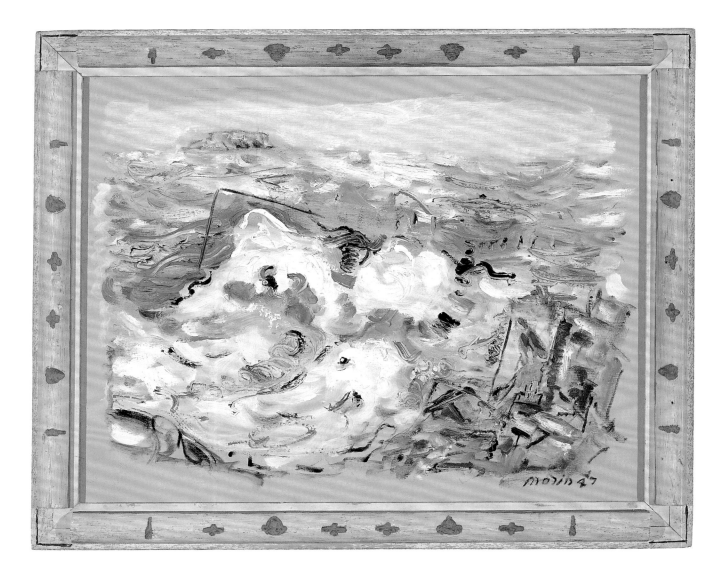

PLATE 1

John Marin *Movement: Seas after Hurricane Red, Green and White, Figure in Blue*, 1947

Preface

WILLIAM C. AGEE

1 For a full discussion of the history of the Addison Gallery and its collections, see Susan Faxon, Avis Berman, and Jock Reynolds, *Addison Gallery of American Art: 65 Years— A Selective Catalogue* (Andover, MA: Addison Gallery of American Art, 1996). See also the catalogue entries on the individual artists in the collection discussed in this essay.

2 Stuart Davis to Alfred H. Barr Jr., November 3, 1952. In this letter, Davis explains the phrase as it appears in his 1951 painting *Visa* (The Museum of Modern Art, New York), reprinted in Diane Kelder, ed., *Stuart Davis* (New York: Praeger, 1971), p. 100. For a fuller discussion of the phrase, see William C. Agee, "Stuart Davis in the 1960s: 'The Amazing Continuity,'" in Lowery S. Sims et al., *Stuart Davis American Painter* (New York: The Metropolitan Museum of Art, 1991), pp. 82–96.

SINCE ITS OPENING some seventy-five years ago, in 1931, the Addison Gallery of American Art, on the campus of Phillips Academy in Andover—the institution from which the art in *Coming of Age* is drawn—has been defined by the exceptional quality and range of its collections. It could not have been otherwise, beginning as it did with acclaimed paintings by Winslow Homer and Thomas Eakins, among others, icons for countless students and the public alike. By 1952, when this author entered the school, the Addison Gallery could show not only masterpieces of American art by Homer and Eakins but also equally great modern paintings by Stuart Davis, Edward Hopper, Georgia O'Keeffe, and even Josef Albers and Jackson Pollock, two cutting-edge artists rarely seen in museums in those days. In fact, by then the Addison could present the best condensed history of American art in the country.[1]

To this day, more than three-quarters of a century later, the first glimpse of that history of American art, from John Singleton Copley to Pollock—provided by the great teachers at the Addison, Bartlett Hayes, Patrick Morgan, and Diz Bensley— remains vivid, literally unforgettable, to this alumnus. We are still learning from it, for that history forms, to paraphrase Stuart Davis, "an amazing continuity"[2] between past, present, and future. In a postmodern age that values disjunction and disconnection, the very idea of continuity may seem to be an anachronism. Nevertheless, for many who have studied American art at the Addison—among them, this writer (Phillips Academy,

class of 1955), artist Frank Stella (1954), and Jock Reynolds (1965), former director of the Addison—a sense of the essential continuity within the collection has defined the experience.[3] That continuity has grown as the collections have grown, and today it is more evident than ever. It is a continuity that speaks to us of the core concerns of American art and, indeed, of the very nature of American art and of all art in its broadest and most fundamental sense. From this essential continuity springs our perception and understanding of the multiple themes and traditions that have been central to American art over the last century and have brought it to full maturation. The rise of American art to a position of world leadership after 1945, now an accepted fact of art history, did not happen overnight. Nor did it come solely from European sources. Rather, it came equally through the development and growth of certain qualities and traditions inherent in America and its art from the start.

3 See especially William C. Agee's entry on Frank Stella in Faxon, Berman, and Reynolds, *Addison Gallery of American Art*, p. 273.

Americans struggled with issues of artistic identity as far back as Durand. As the second half of the nineteenth century progressed, cultural confidence allowed American artists to assimilate and transform European training into distinctly American expressions. In the twentieth century, American art grew in stature and achievement over the course of three generations of great artists, each building on what had come before, each extracting from the earlier generations the means to extend the language of art, a process Europe was unable to maintain, thus bringing America to the position it still holds today. We can now identify these generations as the pioneering generation of 1914, including Patrick Henry Bruce, Arthur Dove, Marsden Hartley, and Georgia O'Keeffe; the generation born roughly between 1900 and 1915, including William Baziotes, Jackson Pollock, Ad Reinhardt, Mark Rothko, and David Smith, as well as Josef Albers and Hans Hofmann; and the generation born between 1925 and 1938, most notably Donald Judd, Sol LeWitt, Robert Mangold, Richard Serra, and Frank Stella.

For seventy-five years and more, the Addison has been a place of discovery: self-discovery, the discovery of art itself, what art is, what great art is; the discovery of individual artists and their work, and of the connections, themes, and continuities that link and bind them in a history of exalted achievement in America. We constantly discover anew, as the artist discovers, for the art changes as we change, thus revealing new themes and connections over a century and more, leading to an ever-deeper understanding of the course of American art.

To see the Addison's collection over time is to be reminded of the continued vitality not only of American art but of painting itself, periodically held to be irrelevant or even dead, no longer meeting the needs of the late twentieth and now twenty-first centuries. But American painting at the Addison, early and later, reminds us that it is alive and well. It tells us that good art is always relevant, that it continues to speak to us with the

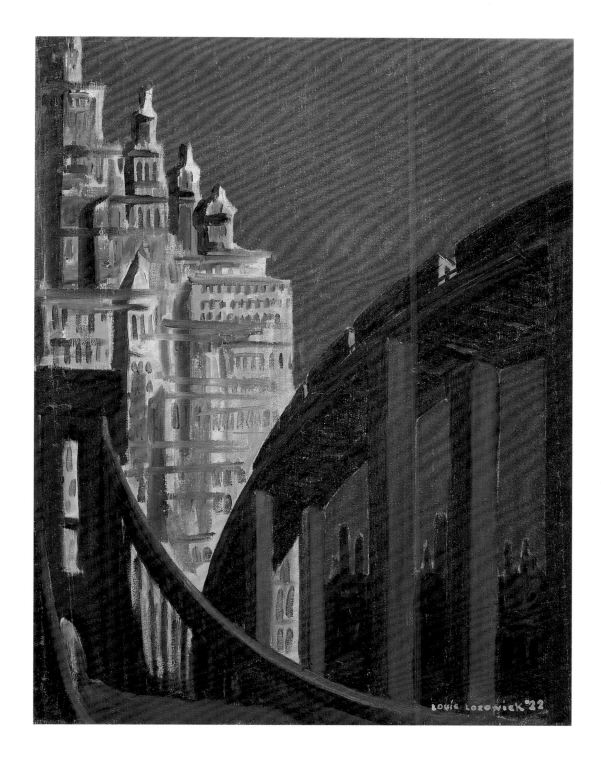

Louis Lozowick *Painting Sketch No. 2—New York,* 1922

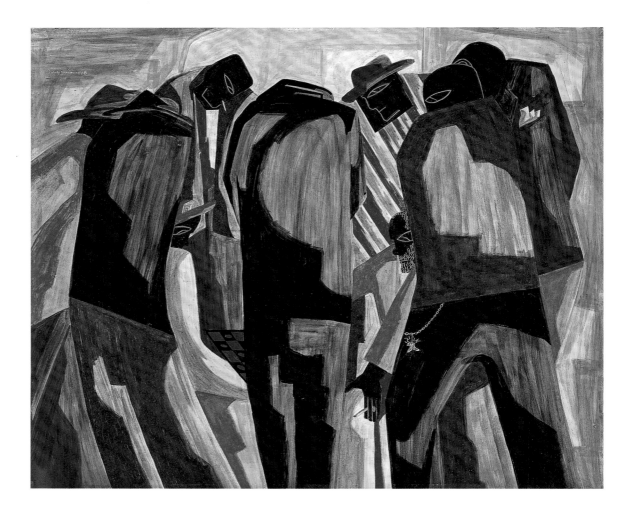

PLATE 3

Jacob Lawrence *Kibitzers*, 1948

voice of personal conviction, born of authentic experience, that affects us in the deepest, most fundamental ways.

American art before 1945 has often been thought to be inferior to European art, but from our first encounters with great painting at the Addison, it became clear that this was not true. Perhaps it was not as deep as European art, but, at its best, certainly not inferior. The paintings we students saw in the Addison inspired us in the fifties, as they still do, a half-century later. Combined with great courses in American literature and a famous American history course, as well as a virtual on-campus laboratory of American architecture from Charles Bulfinch to Frederick Law Olmsted, the art collections at the Addison in effect have formed a brilliant American studies program for Andover students, indeed for all visitors to the campus and museum. Together, they demonstrate that American art and culture are first-rate, quite enough for a lifetime of study and work.

From the collections at the Addison—still housed in arguably the best, most intimate galleries in the country, thankfully little changed—we are constantly reminded of the importance of experiencing works of art firsthand, in one-on-one encounters. From the start, this been the essence of teaching the visual arts at Andover, and for good reason, for it is neither sentiment nor theory; these encounters are real, immediate, transforming. The greatness of the collections is a fact of experience. It is what has made the Addison a great teaching museum, in the best sense of the term, because it taught us what good art is, what makes it great. Who among us at Andover can ever forget our first encounter with Homer's *Eight Bells*, so compelling, one now understands after many long years, because these sailors, finding their way amid the vastness of the stormy and unknown sea and cosmos, exactly mirrored the plight of young students, adolescents trying to find their own way in a new and perilous place, in a world beyond their control.

Essential qualities of American art that inform and define its continuity are everywhere evident in the 1850s to 1950s, especially the often noted sense of American optimism, the sense that everything and anything was possible here. This optimism is evident even in *Eight Bells*, for despite the stormy weather, it shows men bravely facing the vast sea, nature, and a new world, as well as in *Phosphorescence* by Jackson Pollock, an artist starting the painting process from scratch, exploring the unknown, unafraid to ask even the most basic questions about what a painting could be. It is evident in the quiet landscapes of Arthur Dove, Asher B. Durand, and John Twachtman, who, each in his own way, drew on a quiet but unshakeable connection with the land. This optimism is equally apparent in the dynamic urban spectacles of Childe Hassam and Louis Lozowick, as well as the soaring industrial buildings of Charles Sheeler. It is in the energy of the picture, in the paint itself, that this American dynamism makes itself felt, remind-

ing us of the important lesson that it is just as modern to paint a rural landscape as it is a more contemporary and novel spectacle of the city. The underlying energy and vitality in each type of painting also remind us that there is a difference between an American subject and an American style, an important distinction, for confusion between them has often clouded a clear view of American art. It also tells us that good art does not have to be spectacular, but rather is often quiet and apparently unassuming, or even modest, in demeanor.

Other connections and continuities within American art abound at the Addison. The collections teach us that while American art has its own special qualities, it also demands to be considered a part of world culture, and as a part that can well hold its own. This is as true for the earlier as well as for post-1900 art. American art after 1908, the year Alfred Stieglitz began his program of modern exhibitions, was an intrinsic part of a broad drive in the West toward a modernist view of art and life, centered first in Paris, but with important concentrations in Germany, the Netherlands, Russia, and most certainly the United States. Modernism came of age in America in the early years of the twentieth century, establishing a tradition that set the stage for New York to assume its position as the center of world art during and just after World War II. Seeing modern art at the Addison, we can understand the continuity not only between pre- and post-1900 art but between pre- and post-1945 American art. This is particularly important for a fuller, more comprehensive view of the twentieth century. Often the art made in America before and after World War II has been treated as if it were divided by a virtual iron curtain, almost as if it sprang from two entirely different ages and cultures.

In this book, Susan Faxon and I connect the last half of the nineteenth century with the first half of the twentieth. This allows us to identify several themes and traditions that form an ongoing continuity within the whole of American art. The paintings engage us and one another, speaking across the centuries, reminding us of Henry James's comment that "experience is never limited, and is never complete."[4] We often think of modern art primarily in terms of revolution, as a complete break with the past, and in certain ways it was, but just as often it preserves, in new terms, those elements that it holds to be important and thus speaks to both the past and present, even as it looks to the future. By traditions, themes, and continuity, we do not mean something dry, arcane, belonging to the academic and antiquarian, but a living, vital, creative force from which the artist extracts new possibilities through what the great American artist David Smith termed the "visionary reconstruction of art history."[5] To see and understand the continuity of American art is to foster connections, expose deep structures, and bring together a body of wide-ranging and apparently diverse materials to reveal new meanings. At heart, it is this process that accounts for the coming of age of American art.

4 Henry James, "The Art of Fiction" (1884), quoted in David Anfam, "Pollock Drawing: The Mind's Line," by David Anfam in *No Limits, Just Edges: Jackson Pollock Paintings on Paper* (Berlin and New York: Deutsche Bank and Solomon R. Guggenheim Foundation, 2005), p. 26 and 47n.

5 David Smith, "Second Thoughts on Sculpture," *College Art Journal* (Spring 1954), reprinted in *Readings in American Art since 1900: A Documentary Survey*, by Barbara Rose (New York: Praeger, 1968), p. 191. For a compelling and revealing account of how one major artist, Frank Stella, saw and engaged the history of art, at the Addison Gallery of American Art, and elsewhere, see *Frank Stella, Working Space* (Cambridge, MA: Harvard University Press, 1986), and William Rubin, *Frank Stella* (New York: The Museum of Modern Art, 1970).

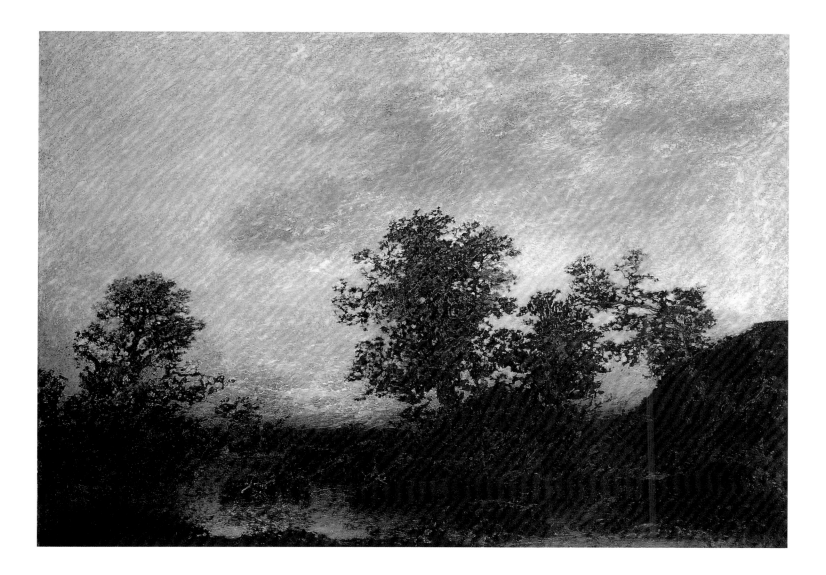

PLATE 4

Ralph Blakelock *After Sundown*, ca. 1892

Acknowledgments

THIS BOOK AND THE EXHIBITION IT ACCOMPANIES mark the coming together of two venerable institutions, the American Federation of Arts, which since 1909 has been organizing traveling art exhibitions of the highest caliber, and the Addison Gallery of American Art, whose holdings constitute one of the most important collections of American art in the United States. With *Coming of Age*, we are delighted to be able to investigate a seminal one-hundred-year period in the history of American art.

We wish to acknowledge the curatorial team, Guest Curators William C. Agee, Evelyn Kranes Kossak Professor of Art History at Hunter College, New York, and Susan C. Faxon, Associate Director and Curator at the Addison Gallery, both for their astute selection of the works in the exhibition and their insightful contributions to this book. They have each given generously of their time and talent.

At the AFA, the dedication of numerous staff members contributed to the success of *Coming of Age*. Susan Ross, Curator of Exhibitions, adeptly organized all aspects of the project with the help of Curatorial Assistant Maria Dembrowsky. The production of this handsome and important catalogue was skillfully managed by Michaelyn Mitchell, Director of Publications and Design, with the very capable assistance of Alec Spangler, Editorial Assistant. Kathleen Flynn, Interim Director of Exhibitions and Programs, carefully oversaw many of the details of the exhibition tour. In conjunction with the Addison Gallery staff, Eliza Frecon, Registrar, and Anna Hayes, Head Registrar, expertly supervised the care and installation of the objects throughout the exhibition tour. We would also like to acknowledge Suzanne Burke, Director of Education; Kathryn Haw, Director of Corporate and Foundation Relations; and Anne Palermo, Grant Writer.

On behalf of the Addison, we would like to thank the museum's remarkably hard-working staff members who make everything we do seem effortless and elegant. Denise Johnson and James Sousa of the registrarial department handled all of the permissions, list making, insurance, and travel arrangements, and preparatory staff members Leslie Maloney, Brian Coleman, and Austin Sharpe assessed condition and readied each work for safe travel, each with their usual mastery. Curatorial Associate Juliann McDonough coordinated the myriad curatorial details with great aplomb.

Maria Lockheardt ably coordinated fundraising efforts for the Addison in close consultation with AFA. Finally, we offer thanks to our photographers, Greg Heins and Frank E. Graham, who brought their skill to bear in the production of the sparkling images in this book.

The publication has benefited from the efforts of Stephanie Salomon, who carefully edited the texts; and Barbara Glauber and Emily Lessard of Heavy Meta, who created such a sympathetic and elegant book design. We would also like to acknowledge our publishing partner, Yale University Press, in particular, Patricia Fidler, Senior Editor.

We would like to express our wholehearted thanks to the Philip and Janice Levin Foundation, whose generous support of the AFA's research and development of collection-based exhibitions ensures that the organization can continue to bring world renowned collections to audiences across the United States. We also wish to acknowledge the generosity of The Crosby Kemper Foundation, Frank B. Bennett, and William D. Cohan, whose contributions to the exhibition have helped make its realization possible.

Finally, we recognize the museums participating in the tour of this important exhibition, following its opening at the Addison Gallery of American Art—the Meadows Museum of Art in Dallas; the Dulwich Picture Gallery in London; the Peggy Guggenheim Collection in Venice; the Museum of Art, Fort Lauderdale, Nova Southeastern University; the Musée national des beaux-arts du Québec—and in particular the respective directors, Mark Roglán, Ian Dejardin, Philip Rylands, Irvin M. Lippman, and Esther Trépanier. It has been a pleasure to work with such respected institutions and individuals, and we thank them for their enthusiastic partnership in and support of *Coming of Age*.

JULIA BROWN
DIRECTOR
AMERICAN FEDERATION OF ARTS

and

BRIAN T. ALLEN
THE MARY STRIPP AND R. CROSBY KEMPER DIRECTOR
ADDISON GALLERY OF AMERICAN ART

PLATE 5

Asher B. Durand *Study of a Wood Interior*, ca. 1855

SUSAN C. FAXON

The Search for an American Expression, 1850–1917

IN 1855 THE PAINTER ASHER B. DURAND (1796–1886) offered the following advice to students of art:

> Go not abroad then in search of material for the exercise of your pencil, while the virgin charms of our native land have claims on your deepest affections. Many are the flowers in our untrodden wilds that have blushed too long unseen, and their original freshness will reward your research with a higher and purer satisfaction, than appertains to the display of the most brilliant exotic. The "lone and tranquil" lakes embosomed in ancient forests, that abound in our wild districts, the unshorn mountains surrounding them with their richly-textured covering, the ocean prairies of the West, and many other forms of Nature yet spared from the pollutions of civilization, afford a guarantee for a reputation of originality that you may elsewhere long seek and find not.[1]

When Durand penned this paragraph for publication in an art magazine, he was participating in a debate that had been gripping American artists for a number of years. While American political independence had been assured late in the previous century, American artistic independence was debatable. Could American art stand on its own against the long traditions of European art? How would American artists find an artistic voice distinct from that of their European counterparts? Just what was American about American art?

This essay traces the transformation of American art from the mid-nineteenth century into the beginning of the twentieth century as artists in this country navigated

1 Asher B. Durand, "Letters on Landscape Painting, Letter 1," *The Crayon* 1, no. 1 (January 17, 1855): 2.

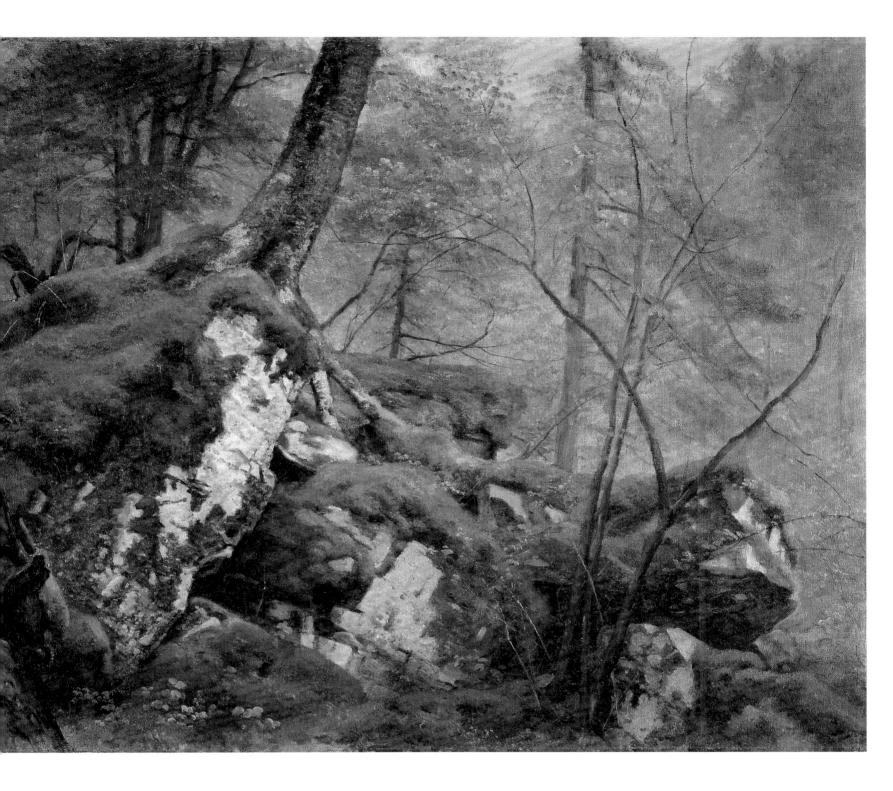

PLATE 6

Martin Johnson Heade *Apple Blossoms and Hummingbird,* 1871

their way to the adoption of a distinct American expression. The trajectory begins with Durand, a founding Hudson River painter who depicted the lush American landscape in precise and meticulous detail, and ends with the Ash Can painter George Bellows (1822–1925), who joined other early twentieth-century artists in capturing the life and bustle of the modern urban environment.

An examination of the ideas embedded in Durand's 1855 recommendations to budding artists affords the opportunity to explore the mid-nineteenth-century cultural climate and to establish the basis for the development that would follow. Durand's advice was part of a series of nine articles that the artist wrote, published under the rubric "Letters on Landscape Painting," which appeared biweekly in issues of *The Crayon*, starting on January 3, 1855, and ending on July 4 of that year. The series provides a meaningful dissertation on and distillation of the goals of mid-nineteenth-century landscape painting, objectives that were shared by many in Durand's generation.

Arguing that the proper subject for American painting was the American landscape, a fresh, untrammeled natural paradise that the tired, overworked European terrain could not match, Durand exhorted young artists to take up the brush, clear their eyes, and begin a detailed study of the physical facts of nature.

> *Let me earnestly recommend to you one STUDIO which you may freely enter, and receive in liberal measure the most sure and safe instruction ever meted to any pupil, provided you possess a common share of that truthful perception, which God gives to every true and faithful artist—the STUDIO of Nature.*"[2]

2 Durand, "Letters on Landscape Painting, Letter 1," *The Crayon* 1, no. 1 (January 3, 1855): 2.

Durand's oil *Study of a Wood Interior* is a striking manifestation of the artist's charge to students. In this close-up view of a densely packed fragment of impenetrable nature, the artist has lovingly depicted the tumble of rotting logs and lichen-covered rocks of the forest floor where only brief moments of filtered sunlight disturb the verdant quiet. This painting is one of a remarkable series of nature studies that Durand completed in the early 1850s. Although he identified them as studies, the artist exhibited these works—to critical acclaim—as complete statements, despite the fact that they were small in scale and focused in viewpoint. *Study of a Wood Interior* is visual testimony to Durand's instruction to students to turn their attention to the "minute portraiture" of the "most simple and solid materials, such as rocks and tree trunks," in order to learn "their subtlest truths and characteristics, and thus knowing thoroughly that which you paint, you are able the more readily to give all the facts essential to their *representation*."[3]

PLATE 5

3 Durand, "Letters on Landscape Painting, Letter 5," *The Crayon* 1, no. 10 (March 7, 1855): 145.

In many ways Durand's "letters" represent a philosophical bridge between the

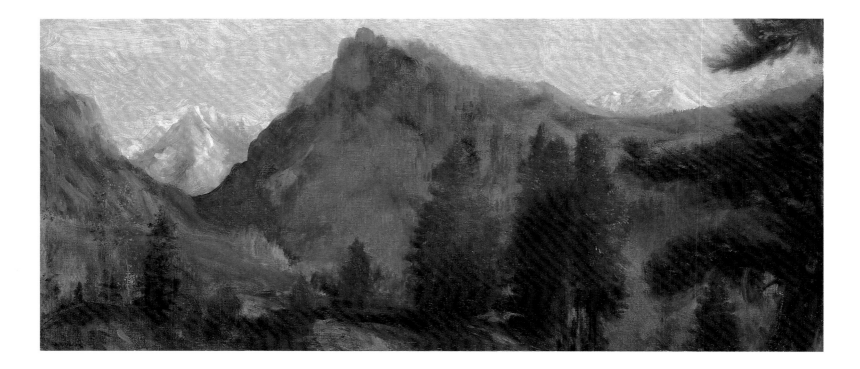

Arthur B. Davies *Mountain Beloved of Spring,* ca. 1906–07

Romantic concepts of painting from nature that had informed such artists as Thomas Cole (1801–1848) and had occupied such philosophers as Ralph Waldo Emerson, Samuel G. Ward, and other Transcendentalists, and a later generation that turned away from the expansive, large-scale paintings of Frederic E. Church (1826–1900) and Albert Bierstadt (1830–1902) to find quieter moments in sky and light. Durand's words reveal two significant beliefs: the ability of nature to be morally uplifting and to reflect spiritual truths; and the desirability of turning to the resources and imagery of the American landscape to discover the American-ness of this country.

Thomas Cole, who along with Durand represented the first generation of the Hudson River painters, believed fervently in the power of the painted landscape to lift and open the heart and mind to the spirit of God, a belief he shared with Durand. Yet the two artists differed in the artistic expression they would employ to accomplish this lofty ambition.

Cole's paintings, fully engaged with the theories of the Romantics, were given drama through the portrayal of sublime nature—wild nature untouched by humans, as God had created it. For Cole, such nature had the power to instill the emotion of fear and awe, moving viewers to a spiritual state that would pay homage to God. Motivated by a belief in painting as "a holy mission,"[4] Cole constructed his impressive panoramic landscapes from exacting studies of nature, brought back to the studio for absorption and interpretation as the ideal land. Writing to his patron Robert Gilmor in 1825, Cole explained his belief that the artist must gather material from nature, and then recompose that information into a coherent whole. He noted that

> a departure from nature is not a necessary consequence in the painting of compositions: on the contrary, the most lovely and perfect parts of nature may be bought together, and combined in a whole, that shall surpass in beauty and effect any picture painted from a single view.[5]

It was a practice that Durand also adopted for most of his major landscape paintings. Large in scale and ambitious in their expansive view, Durand's composite landscapes, like those of Cole and other Hudson River painters, hewed closely to the Romantic models of composition, coloration, and conventions established by such European painters as Claude Lorraine. Yet Durand's studio paintings, like many of Cole's, portrayed a distinctly American landscape, in which both artists believed could be found spiritual solace and joy. Echoing Cole, Durand wrote:

> There is yet another motive for referring you to the study of Nature early—its influence on the mind and heart. The external appearance of this our dwelling-place, apart from its wondrous structure and functions that minister to our well-being, is fraught with lessons of high and holy meaning, only surpassed by the light of Revelation.[6]

4 Roger B. Stein, *John Ruskin and Aesthetic Thought in America, 1840–1900* (Cambridge, MA: Harvard University Press, 1967), p. 26.

5 Louis L. Noble, *The Course of Empire: Voyage of Life, and Other Pictures of Thomas Cole* (New York: Cornish, Lamport & Company, 1853), pp. 93–94.

6 Durand, "Letters on Landscape Painting, Letter 2," *The Crayon* 1, no. 3 (January 17, 1855), p. 34.

As *Study of a Wood Interior* attests, Durand was also willing to look closely and to faithfully transcribe a view of nature in its own pristine presence. This work, like his other studies of the 1850s, eschewed Cole's narrative intent. Durand lets nature speak its own language, even if that language carries a spiritual tone.

In admonishing art students not to go abroad for their subject material, Durand was also voicing an American concern for the corrupting influence of Europe, a national attitude that had roots in this country's earliest history. Eighteenth-century colonists had had deep misgivings about the arts, which they characterized as luxuries. Early statesmen such as John Adams and Benjamin Franklin, who were dispatched to France to negotiate support for the patriotic cause, sent letters full of admiring yet distrustful impressions of the French culture.

John Adams, writing to his wife, Abigail, from Paris in 1780, described the sights of the city as pleasant and instructive, even seductive, but nevertheless warned, "It is not indeed the fine Arts, which our Country requires. The Usefull, the mechanic Arts, are those which We have occasion for in a young Country, as yet simple and not far advanced in Luxury."[7] Many shared Adams's distrust of what he called "Bagatelles, introduced, by Time and Luxury in Exchange for the great Qualities and hardy manly Virtues of the human Heart."[8] While luxurious objects—clothing, silver, furnishings— were accepted accoutrements of the affluent colonial household, fine arts in the form of paintings were regarded as extraneous and indulgent. This view of the arts persisted well after American independence was won. For the eighteenth-century American colonists, culture was irrefutably and inevitably European; the issue of how or if to integrate the arts into their own lives could not be addressed until economic stability had been attained.

By the 1840s, however, cultural self-determination occupied the minds of artists and critics alike. There were those who felt that art in America should develop only through attention to the native landscape. Others argued that "to cut ourselves off from the European traditions of art was a form of cultural suicide."[9] If America's artistic heritage was inescapably based on European sources, then European tradition was the only standard by which Americans could judge their artistic and cultural value. Oliver Wendell Holmes had argued in his 1840 review of an exhibition of work by the American painter Washington Allston that Americans would necessarily turn to Europe, saying "we must look for the scale by which to measure any degree of excellence, that passes our ordinary standard of judgment."[10]

In the mid-nineteenth century, in any case, the adoption of the natural world of America as the great subject matter for artists was proving problematic as settlers cleared forests, built houses, laid tracks, and developed manufacture and commerce.

7 L. H. Butterfield, Marc Friedlaender, and Mary-Jo Kline, eds., *The Book of Abigail and John: Selected Letters of the Adams Family, 1762–1784* (Cambridge, MA: Harvard University Press, 1975), pp. 259–60.

8 Ibid., p. 210.

9 Stein, *John Ruskin and Aesthetic Thought*, p. 14.

10 Ibid., p. 16.

PLATE 8

Eastman Johnson *The Conversation*, 1879

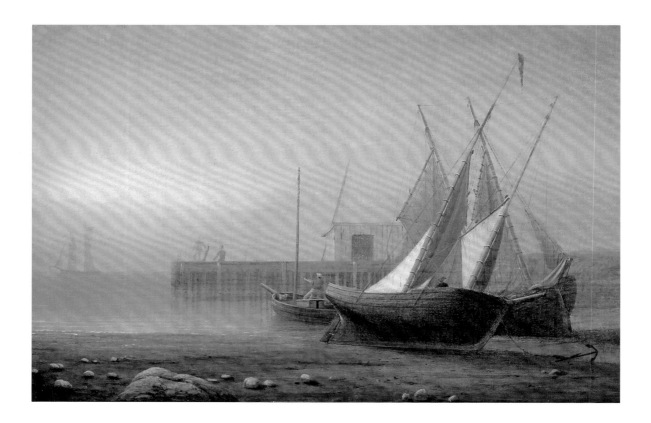

PLATE 9

Fitz H. Lane *Fishing Boats at Low Tide*, ca. 1850–59

11 Quoted in Perry Miller, *Nature's Nation* (Cambridge, MA: The Belknap Press of Harvard University Press, 1967), p. 197.

Cole bemoaned the destruction of virgin forests to accommodate the march of civilization. In 1847, fellow painter Jasper F. Cropsey (1823–1900) urged artists to capture on canvas those vanishing parts of the American countryside before they gave way to the "the axe of civilization."[11] If the proper subject matter for American art was the American land, and the resulting images the true path to spiritual enrichment, what would happen when grain silos and train trestles and riverboats took the place of the untrammeled forest floor or stream bed? It was clear that American art would have to define itself in a less parochial and isolationist way, and by the 1850s some were ready to open the door a crack.

As Durand's letters of advice suggested, mid-nineteenth-century American painters were hungering for instruction, for learning the tools of the trade. Earlier artists had traveled to European museums and palaces to experience firsthand the cultural treasures of Western civilization. While most mid-century artists still considered the European tour essential for artistic learning, now a few adventurous artists actually enrolled in European schools and ateliers in Düsseldorf, Munich, and Paris. The Boston-born painter William Morris Hunt (1824–1876) was a pioneer when he joined German-American painter Emanuel Leutze (1816–1869) in Düsseldorf in 1845–46. Two years later he moved to Paris where his brother, the architect Richard Morris Hunt (1827–1895), had enrolled at the Ecole des Beaux-Arts in 1846. Hunt studied painting in Paris with Thomas Couture and followed the French artist Jean-François Millet into the Barbizon countryside a year later. Eastman Johnson (1824–1906), who honed his early skills making charcoal portraits and returned to paint powerful and haunting genre scenes such as *The Conversation*, left Boston in 1849 with a fellow Bostonian to enroll in the Düsseldorf academy and to work with Leutze. Two years later he was sharing living quarters with the Cincinnati-born Worthington Whittredge (1820–1910). These early forays were the beginning of what became de rigueur for Americans, who in short order enrolled in large numbers in classes in the capitals of Europe.

PLATE 8

The 1850s also witnessed potential patrons and critics sharpening their skills of discernment by traveling to the cultural sites of Europe. Tourists wrote of the awe-inspiring experience of seeing great European art. Mid-nineteenth-century travelers were bringing back European works of art to hang in their homes. As the editor of *Harper's New Monthly Magazine* wrote in January 1855, "Nothing in the growth of New York is more surprising than the increase of taste for works of art....At this moment, in two of [the storefront galleries], original works of one of the most distinguished living English artists [Edward Landseer], and of one of the very first of the Frenchmen [Ary Scheffer's *Temptation*], are to be seen for the trouble of stepping in from the street."[12]

12 "Editor's Easy Chair," *Harper's New Monthly Magazine* 10, no. 56 (January 1855): 267.

Continuing, the writer introduced a noteworthy incentive for collecting European art:

The presence of these two pictures among us marks an era. In such ways New York begins to be a metropolis. We begin to feel that we need not cross the sea always, or that our children need not, to know what is rife in the World of Art. Such works are the advance-guards and outposts of the coming Muses. They persuade us that we may be not only rich, but may worthily use riches.[13]

13 Ibid., p. 268.

Here then was an attitude in direct contradiction to the worries of earlier generations about the corrupting influence of art on American society. European art was coming across the ocean, and its presence would enhance and enlighten the increasingly prosperous American public.

This was both good news and bad for American artists. It meant that a public more receptive and knowledgeable about art was developing, one that could well produce a larger body of patrons. On the other hand, the taste that was developing focused heavily on European art, where the emphasis was on figure and history painting. American scenes by American painters were less desired in the rush to outdo one's neighbor with the tangible display of cosmopolitanism and social position. American landscape painting, with its fresh earnestness and deliberate parochialism, lacked the patina of Old World age and sophistication.

The increasingly literate public was being educated about art in other ways as well. Cheaper pulp paper, innovations in printing presses, and reduced costs in both shipping and postage transformed American publishing into a booming industry. Concentrated in the cities of New York, Philadelphia, and Boston, large-scale publishers produced books and magazines for a national audience. In addition, by the early 1850s, the laying of a network of telegraph wires allowed cities across the nation to share information electronically, and near the end of the decade, in 1858, international news became accessible via the transatlantic cable.[14] Europe was within reach in ways that it had not been before. Ideas could travel in a matter of minutes and days.

14 Joshua Brown, *Beyond the Lines: Pictorial Reporting, Everyday Life, and the Crisis of Gilded Age America* (Berkeley: University of California Press, 2002), p. 23.

One such transmission of ideas came in the form of English publications. When *Modern Painters*, the 1843 book by English theorist and critic John Ruskin (1819–1900), was released in its American edition in 1847, its author's ideas found fertile American soil in which to grow. *Modern Painters* put forth Ruskin's concepts of art, beauty, and nature. The writer's emphasis on morality, his reverence for nature, the reassuring confidence of his views about art, and the clarity of his call for the merging of the spiritual and the artistic arrived in America just as its citizens were searching for yardsticks with which to assess what they saw.

The Crayon, published by William Stillman (1828–1901) and Asher Durand's son John Durand (1822–1908), was a powerful voice for Ruskin's ideas in America.

PLATE 10

Jasper F. Cropsey *Greenwood Lake, New Jersey*, 1866

Unknown before 1847, by 1855 Ruskin could write to *The Crayon's* editors that he felt he had a more enthusiastic audience in America than in England.[15] That very same year, Asher Durand's nine letters on landscape painting were published in *The Crayon*. The call from Durand, dean of the Hudson River painters, to study and translate onto canvas nature in its minute exactitude, to reveal the hand of God in the blades of grass, and to absorb and give dimension to a spiritual presence echoed ideas of Ruskin. It was the latter, after all, who had written in *Modern Painters*:

> *Yet it is not in the broad and fierce manifestations of the elemental energies, not in the clash of the hail, nor the drift of the whirlwind, that the highest characters of the sublime are developed. God is not in the earthquake, nor in the fire, but in the still small voice.*[16]

The example in Durand's mid-nineteenth-century nature studies of the power of direct observation of nature supported Ruskin's ideal of "truth to nature." Together, they offered the American artist liberation from the Romantic notions of the beautiful, sublime, and picturesque, which sat at the heart of Cole's early Hudson River paintings. While Ruskin believed that God was immanent in nature, he did not associate natural fact with symbolism. Rather, he believed that natural beauty had an uplifting, moral purpose, or, as art historian Roger Stein has put it, "the moral value of a work of art was an inherent part of its beauty."[17] The adoption of Ruskin's lessons was reinforced among American artists of the 1860s who, sympathetic to English Pre-Raphaelites such as John Everett Millet and William Holman Hunt, criticized the large-scale Romantic landscapes of Bierstadt, Cole, and Durand and offered new models for focusing on meticulous, site-specific depictions of nature, often recorded in delicately defined, small-scale watercolors.[18]

It was not only the American Pre-Raphaelites who found painting by mid-century Hudson River painters overblown. A group of the new generation of landscape painters, who have come to be called the Luminists because of their interest in depicting the effects of light, owed their training to the examples of such landscape masters as Cole and Durand, learning from them the panoramic viewpoint, the attention to nature, and the minimization of the artist's hand. Luminists, however, generally avoided the nationalistic narrative and religious fervor of Cole or the theatrics of his follower, Frederic E. Church. Nor did they choose to convey their messages using the large scale of earlier landscape painters. Grandeur and drama gave way to the kind of precision and tight examination that is revealed in the 1850s paintings of Fitz H. Lane (1804–1865).

Lane, locally trained and plying his trade well away from the artistic center of New York, turned his eyes to the bustle of his native town, the port of Gloucester, Mas-

15 Stein, *John Ruskin and Aesthetic Thought*, p. 1.

16 Quoted in Barbara Novak, "On Diverse Themes from Nature: A Selection of Texts," in *The Natural Paradise: Painting in America, 1800–1950*, ed. Kynaston McShine (New York: The Museum of Modern Art, 1976), p. 79.

17 Stein, *John Ruskin and Aesthetic Thought*, p. 40.

18 Linda S. Ferber and William H. Gerdts, *The New Path: Ruskin and the American Pre-Raphaelites* (Brooklyn, NY: The Brooklyn Museum, 1985), p. 12.

sachusetts, as well as to the northeastern Maine coast, transforming the scenes before him into crystalline, time-arrested paeans to nature at its most peaceful. This quieter approach to landscape freed painting from the weighty obligations of narrative. It also broke from the implied notion that all replication of nature required the manifestation of a spiritual message. Human action was subservient to atmospheric phenomena in compositions that lowered the horizon line to give full stage to the interaction of sky, clouds, light, and weather. Explorations of the shifting of light as the sun moved across harbors and shore and the easy integration of human activity within the natural landscape were grist for Lane's artistic mill.

Whereas Church's skies glowed with apocalyptic light, Jasper Cropsey sought, in his own words, "the delicate and evanescent beauty" of the "wide-spread horizon." Describing the ever-changing sky above, he wrote in 1855:

> Here we have, first of all, the canopy of blue; not opaque, hard, and flat, as many artists conceive it, and picture patrons accept it; but a luminous, palpitating air, in which the eye can penetrate infinitely deep, and yet find depth, nor is it always the same monotonous blue; it is constantly varied, being more deep, cool, warm or grey—moist or dry, passing by the most imperceptible gradations from the zenith to the horizon—clear and blue through the clouds after rain—soft and hazy when the air is filled with heat, dust and gaseous exhalations—golden, rosy, or green when the twilight gathers over the landscape; thus ever presenting new phases for our admiration at each change of light or circumstances.[19]

19 Jasper F. Cropsey, "Up Among the Clouds," *The Crayon* 2, no. 6 (August 8, 1855): 79.

This poetic view of sky and clouds was given advantageous play in Cropsey's subtle and tranquil canvases of bucolic New England, New York, and New Jersey landscapes. The artist's formative painting style of the 1840s was modeled on views by Cole and other Hudson River painters. Cropsey, too, celebrated the hand of God in nature, writing to his fiancée in 1847, "The voice of God came to me through every motionless leaf, on every blade of grass—the odor of the flower and in every breath of air I drew."[20] Yet, by 1866, the date of his painting *Greenwood Lake, New Jersey*, the message had shifted to one of peaceful accommodation of human leisure within a benign and idyllic landscape. Cropsey had already made two European trips; on his second trip abroad in 1856 he spent time in England developing a friendship with John Ruskin and his circle. Undoubtedly, Ruskin reinforced Cropsey's ability to savor the quiet moments of nature. These tranquil moments found favor among the art-viewing public as well, as the country turned from the didacticism and grandiosity of second-generation Hudson River painters like Church to smaller, more domestic scenes as balm after the upheaval and trauma of the recent Civil War.

20 Jasper F. Cropsey to Maria Cooley, July 4, 1846, quoted in Ella M. Foshay and Barbara Finney, *Jasper F. Cropsey: Artist and Architect* (New York: The New-York Historical Society, 1987), p. 27.

PLATE 10

The interests of the Luminists and the influences of European trends in painting converged in the work of landscape painters of the 1870s and 1880s. American

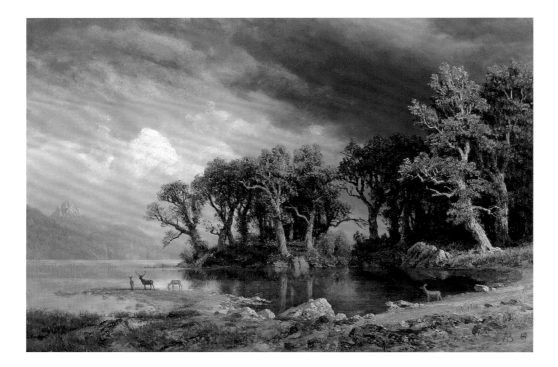

Albert Bierstadt *The Coming Storm*, 1869

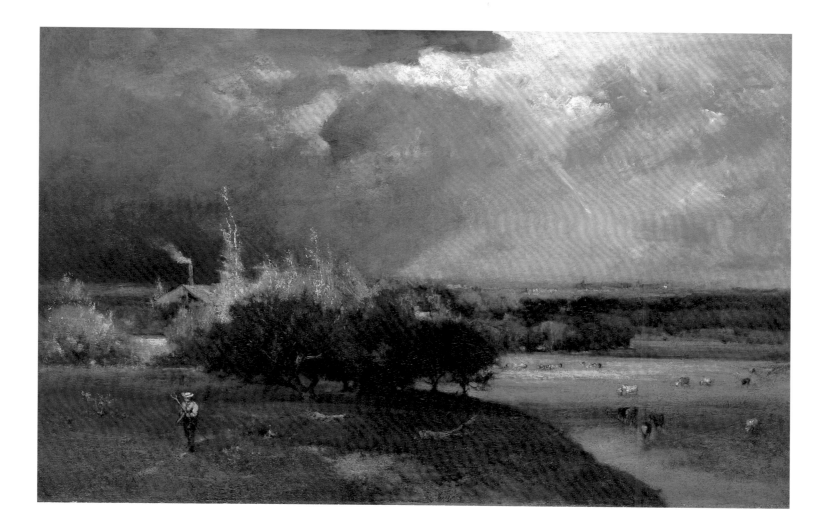

PLATE 12

George Inness *The Coming Storm*, ca. 1879

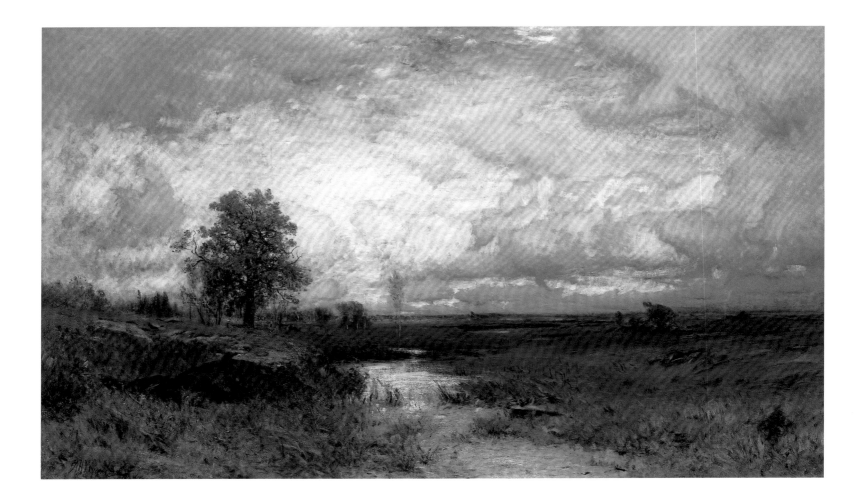

PLATE 13

Alexander Wyant *Landscape,* ca. 1880–89

students who spent winters in Parisian ateliers made their way to the French country-side in the warmer months where they found French painters responding to the rural life and the lush cultivated forests of Fontainbleau and the Barbizon region. Here, French artists, among them, Camille Corot, Charles-François Daubigny, and Jean-François Millet, moved out of the studio to capture spontaneous scenes in the open air, a practice known as plein-air. They relinquished the tight, precise finish that would have been expected as the final step in creating a painting in their academic training and exalted in the free brushwork of the ébauche, or sketch. The freshness of the technique, married with the inspiration of simple country life, produced a far different result from the studied, deliberate Salon paintings of classical and/or historical subjects. American students, among them, William Morris Hunt, George Inness (1825–1894), and Alexander Wyant (1836–1892), were inspired by the French examples; and their paintings also reflected a more relaxed technique, a fondness for country scenes, and a delight in full painterly strokes and emotive skies. Colors too softened to the grays and taupes of the ordinary landscape. Eschewing the precision and clarity of their Luminist counterparts, these American painters reveled in the exuberant and unpredictable passages of cloud, storms, and mists. The weather itself became a prominent actor.

Wyant's _Landscape_, painted during the 1880s, attests to the power of this quieter but no less dramatic, plein-air model. Grand in scale, yet soft in character and pensive in tone, Wyant's landscape exploits the drama of the building clouds and the pattern of the gray-green weeds of the marshy foreground, framing the delicate plume of chimney smoke rising from the tiny cottage nestled into the middle ground. In all aspects but size, this American artist had adopted the model of the French Barbizon painter Corot.

PLATE 13

George Inness's _The Coming Storm_, of about 1879, likewise focuses on the drama of active nature. Yet this painting, unlike the passive acceptance of Wyant's waiting landscape, bristles with the tension of the darkening clouds growing behind the unsuspecting farmhand and the cozy farmhouse. How distinctly different in intent is this depiction from _The Coming Storm_ painted by Albert Bierstadt ten years earlier, in 1869. In the latter, an archetypal Hudson River painting, a glassy lake surrounded by virgin land waits in animated suspension as a storm builds in the distance, witnessed only by one of nature's creatures, the woodland deer. For Inness, the landscape has become the domain of human habitation, and the storm, no less dramatic and threatening than Bierstadt's, now promises consequences for humans.

PLATE 12

PLATE 11

Inness brought not only a different choice of scenery and portrayal of natural phenomena to his work, but he espoused a fundamentally oppositional philosophical approach to the art of painting and the goal of art. Whereas Bierstadt and his

generation had married mimetic accuracy with messianic fervor, Inness emphatically rejected the moralizing goal. In an 1878 interview for *Harper's New Monthly Magazine*, he described the painter's intention as "simply to reproduce in other minds the impression which a scene has made upon him." He went on, "A work of art does not appeal to the intellect. It does not appeal to the moral sense. Its aim is not to instruct, not to edify, but to awaken an emotion."[21]

21 "A Painter on Painting," *Harper's New Monthly Magazine* 56 (February 1878): 458.

A singularly articulate if outspoken critic of his contemporaries, Inness, unlike many others, had not studied in European academies. He was self-taught; his theories on art were the result of an introspection that merged instincts for the essential core of ideas with a devotion to the teachings of Swedenborgianism, a spiritual philosophy that posited the correspondence between human beings' inner and outer lives. Even as he eschewed moralizing goals for art, Inness remained firmly committed to the intentional revelation of a deeply felt spirituality, what he called "the inner life." For him, as he wrote, "The true end of Art is not to imitate a fixed material condition, but to represent a living motion. The intelligence to be conveyed by it is not of an outer fact, but of an inner life."[22]

22 "Mr. Inness on Art-Matters," *The Art Journal* 5 (1879): 377, cited in Adrienne Baxter Bell, *George Inness and the Visionary Landscape* (New York: National Academy of Design, 2003), p. 29.

While it is possible to see in Inness's art the influences of Barbizon painterliness and even the quick brushwork and emphasis on light favored by the Impressionists, the artist dismissed all such categorizations of his work. Admitting a deep appreciation for Corot and the other Barbizon painters, he rejected the lack of structure and "pancake of color" of the Impressionists, expressed his scorn for the "puddling twaddle of Preraphaelism," and labeled the work of Monet as "without substance."[23] Instead, he wrote,

23 George Inness, undated, quoted in George Inness, Jr., *Life, Art and Letters of George Inness* (New York: The Century Co., 1917), pp. 168–74.

> *In the art of communicating impressions lies the power of generalizing without losing that logical connection of parts to the whole which satisfies the mind. The elements of this, therefore, are solidity of objects and transparency of shadows in a breathable atmosphere through which we are conscious of spaces and distances.*[24]

24 Ibid., p. 169.

Inness went on to formulate his relationship to the models of the past and his goals for painting in general, which was steeped in tradition yet founded on the emotive inner truth of the artist's eye and mind:

> *The art of painting is the development of the human mind, and to deny its traditions is the sign of an art fool; but to translate its traditions into new forms is the sign of a progressive art mind full and independent in his own concepts of nature, but bound to the past as the source of his inspiration. Originality outside of this truth is childishness, and its products absurd. The first great principle in art is unity representing directness of intent, the second is order representing cause, and the third is realization representing effect.*[25]

25 Ibid., p. 170.

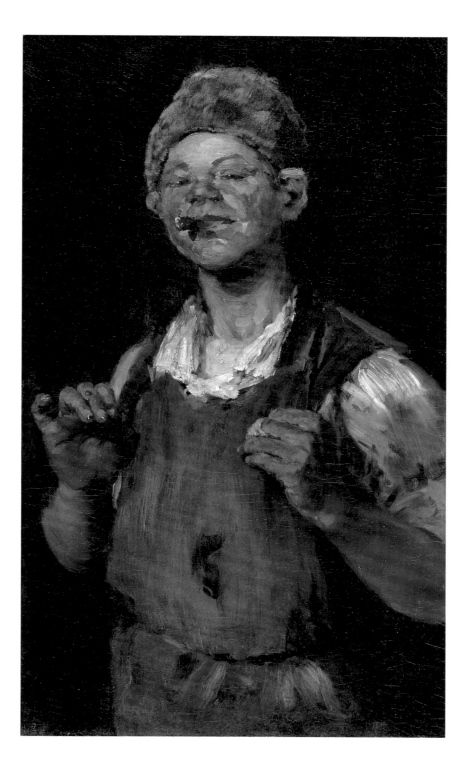

PLATE 14

William Merritt Chase *The Leader*, ca. 1875

In this passage Inness articulated an artistic notion that could embrace the lessons of the past and put those lessons into the service of a new, vibrant expression.

Reviewing an 1879 exhibition of younger artists, critic William Brownell saw evidence of Inness's call for a new progressive art in the work of other artists. The author proclaimed, "Before [the years 1876–78] we had what was called, at any rate, an American school of painting; and now the American school of painting seems almost to have disappeared." The writer condemned the earlier generation of landscape painters as shunning "ideality as something profane, substituting therefore what is known in conservative American art circles as 'truth'" and for substituting "fidelity" for "real truth—the essential, spiritual, vital force of nature, however manifested."[26]

26 William C. Brownell, "The Younger Painters of America: First Paper," *Scribner's Monthly* 20, no. 1 (May 1880): 1. See also ibid., no. 3 (July 1880): 321–35.

The American school to which Brownell alluded was based on the Düsseldorf tradition of high finish and meticulous detail. The younger artists, among whom he counted William Merritt Chase (1849–1916), Frank Duveneck (1848–1916), and Abbott Thayer (1849–1921), learned how to paint in Munich and Paris, and then, with technical principles understood, crafted paintings that were alive with what Brownell called "genuine artistic impulse."[27] Chase's portrait *The Leader* is an example of the joyful exuberance made possible by the virtuoso painterly style he learned from Karl von Piloty in Munich. In words that add support to Inness's exhortations to painters and define Chase's accomplishment, Brownell averred, "Almost without exception, nature is to them a material rather than a model; they lean toward feeling rather than toward logic; toward beauty, or at least artistic impressiveness, rather than toward literalness; toward illusion rather than toward representations."[28]

27 Ibid., p. 8.

28 Ibid.

Brownell's article acknowledged the shift in American art. The hold of those who championed the meticulous recording of nature—a strain that had flowed through the Hudson River School, teaching of the ennobling consequences of attention to God's nature, to John Ruskin's call for heeding nature's "still small voice," to the later Luminists who captured the crystalline air and skies, to those who first ventured abroad to learn the rigorous technique of Düsseldorf—was loosened. Stating boldly that art has no message, Inness adopted an exuberant, energized painterly style to reveal the inner meaning of landscape, a meaning unburdened by moralizing or nationalistic intent.

Younger artists rebelled against the rigidity of established American institutions and the orthodoxy of the older generations who controlled the exhibitions. With European training under their belts, a growing public interested in art, and publications giving space to art criticism, artists were emboldened to find new arenas for showing their work. When the judges of the National Academy of Design's annual exhibition of 1878 restricted the number of works by the younger generation, they created a new

PLATE 14

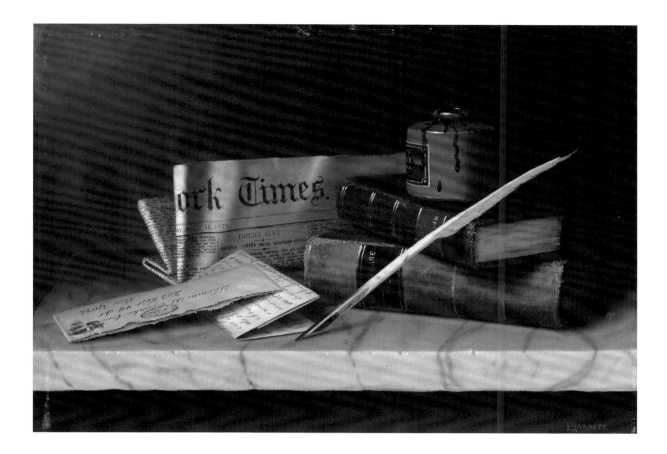

William M. Harnett *Still Life with Letter to Mr. Clarke*, 1879

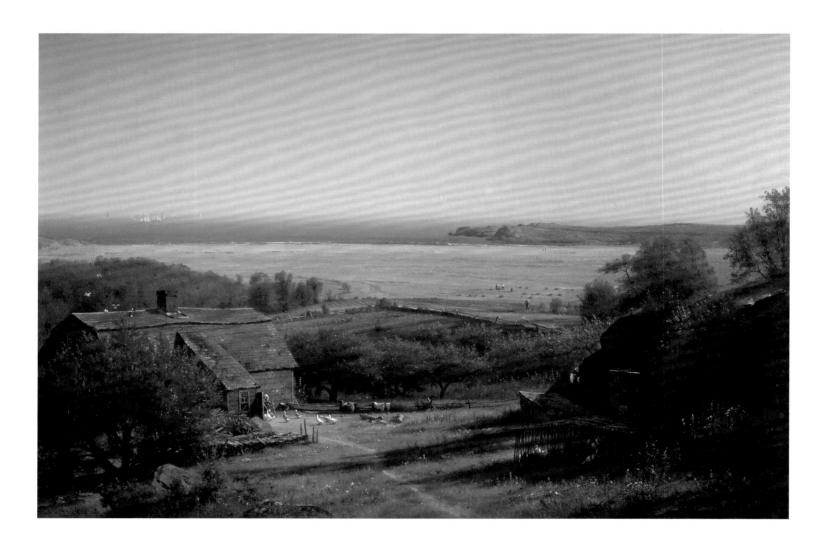

Worthington Whittredge *Home by the Sea*, 1872

forum and a new organization, the Society of American Artists. The group held its first exhibition at New York's Kurtz Gallery in 1878, its second the next year, and it was the latter that prompted Brownell to write his admiring article about the new direction of American art.

In fact, the post–Civil War period marked a time when many cultural organizations developed. The Museum of Fine Arts in Boston and New York's Metropolitan Museum of Art, for example, were both founded in 1870. In New York, art schools like the Cooper Union for the Advancement of Science and Art, founded in 1859, and the Art Students League, established in 1875, provided art instruction for those who could not travel to Europe.

Popular publications proliferated. *The Atlantic Monthly* (founded in 1857), *The Century* (1881), and *Scribner's Monthly* (1870) followed on the heels of *Harper's New Monthly Magazine* (1850). Publications focused particularly on art, such as *The Galaxy* (1866), *Art Amateur* (1879), and the *American Art Review* (1880), took the place of *The Crayon*, which closed its pages in 1861. General-interest magazines like *Harper's* and *Scribner's* offered articles on a full array of popular subjects, including fashion and current events, as well as serialized stories, sprinkled with wood-engraved illustrations. Issues often included a critique of a recent show, an interview with an artist, and commentary on the state of cultural affairs. Critics became increasingly sophisticated in their assessment of the art world and their names became well known. Such exposure raised the general public's familiarity with art and artists, both European and American. This amplified publication and art writing, along with the growing market for European painting among wealthy collectors and the inclusion of European art in annual exhibitions and commercial galleries, provided the budding artist of the 1870s with ready exposure to international trends in art.

Perhaps the most important venue for reflection on new art was the 1876 Centennial Exposition in Philadelphia, a world's fair celebrating the one hundredth anniversary of the signing of the Declaration of Independence. The exposition brought American paintings together with British, French, and German art. Critics and viewers alike were forced to assess their own national efforts in relation to international standards.[29] Whether one believed that the American efforts were lacking or that they held their own in such company, critics, artists, and interested public engaged in the discussion of what American art should be. Could American artists apply the technical lessons learned in Europe to an American expression that was distinct and worthy?

It was a dilemma that Worthington Whittredge had faced when he returned to the United States in 1859, following ten years of travel and study in Europe.

29 Margaret C. Conrads, *Winslow Homer and the Critics: Forging a National Art in the 1870s* (Princeton, NJ: Princeton University Press, 2001), pp. 103–07.

It was impossible for me to shut out from my eyes the works of the great landscape painters which I had so recently seen in Europe, while I knew well enough that if I was to succeed I must produce something new and which might claim to be inspired by my home surroundings. . . . I think I can say that I was not the first or by any means the only painter of our country who has returned from a long visit abroad and not encountered the same difficulties in tackling home subjects. Very few independent minds have ever come back home and not been embarrassed by this same problem.[30]

30 Worthington Whittredge, "The Autobiography of Worthington Whittredge," ed. John I. Baur, *Brooklyn Museum Journal* 1 (1942), quoted in *American Art 1700–1960: Sources and Documents*, ed. John W. McCoubrey (Englewood Cliffs, NJ: Prentice-Hall, Inc., 1965), pp. 119–20.

PLATE 16

In 1872, just a few years before the Centennial galvanized interest in America's colonial past, Whittredge merged his lessons of the panoramic grandeur of the Hudson River school, the glowing tranquility of the Luminists, and the appeal of cultivated landscape in his painting *Home by the Sea*. A nostalgic ode to New England's early history, this painting is a far step from the optimistic panoramas of Whittredge's earlier paintings of western subjects. The backdrop of majestic mountains that dominated the artist's pictures of the West has been replaced by a wide sweep of cultivated marshland below a soft gray-blue sky. Here, the golden light of the dying day caresses the humble scene of an old woman feeding her flocks at the door of her house, which, like her, is the relic of the colonial era. Painted at the end of the Civil War, it is hard not to read into this depiction regret at the passing of a more innocent era. And while Whittredge may have struggled to reconcile his European experiences with his desire to capture the Americanness of his surroundings, this painting testifies that he hewed firmly to the lessons of his native land.

Unlike the earlier calls for a national art, the arguments advanced in the 1870s—for example, those of Inness—replaced faithfulness to the details of nature with a call for feeling, originality, and beauty. Critic George Sheldon claimed that "the sole end of art is the expression of beauty," a trait that would be revealed in an artist's work through adherence to originality. Sheldon was certain that the object of American artists studying abroad "was not to ingraft foreign art upon American art. They wished only to nurture their faculties, to cultivate their tastes, to widen their vision, to increase their knowledge of technique."[31] Calling imitation the death of art, he warned, "'the artist spirit is a spirit of rejoicing in the work of our hands,' not in that of other men's hands. Creation is the very breath of art—not, indeed, creation out of nothing, but creation out of chaos, when the artist spirit broods upon it, and light, order, and beauty come forth."[32]

31 George Sheldon, "A New Departure in American Art," *Harper's New Monthly Magazine* 56 (April 1878): 765.

32 Ibid., p. 768.

The question of beauty was one on which not everyone could agree. In reviewing the 1875 National Academy of Design exhibition, novelist and critic Henry James described Winslow Homer (1836–1910) as a "genuine painter" of "perfect realism," who was not at all interested in issues of beauty. James boldly asserted:

He not only has no imagination, but he contrives to elevate this rather blighting negative into a

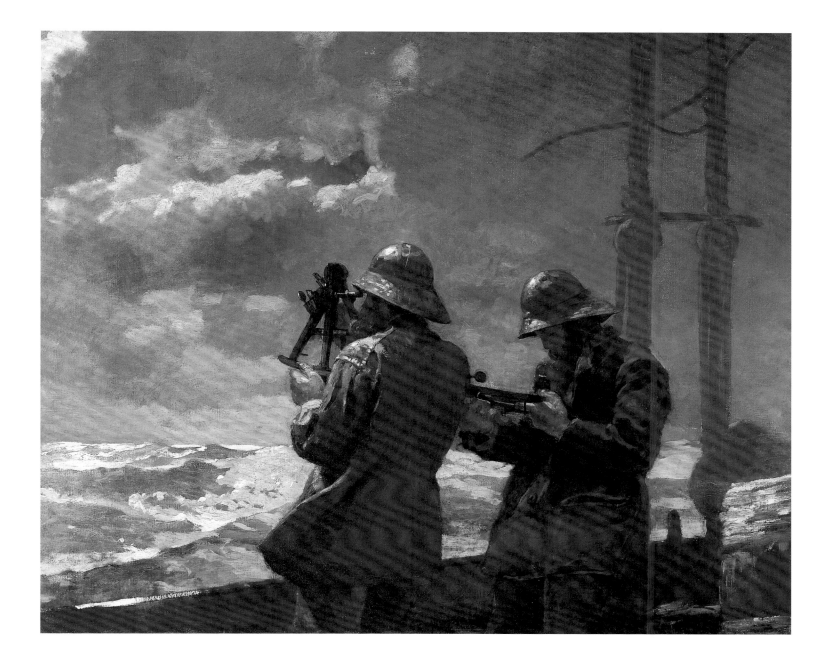

Winslow Homer *Eight Bells*, 1886

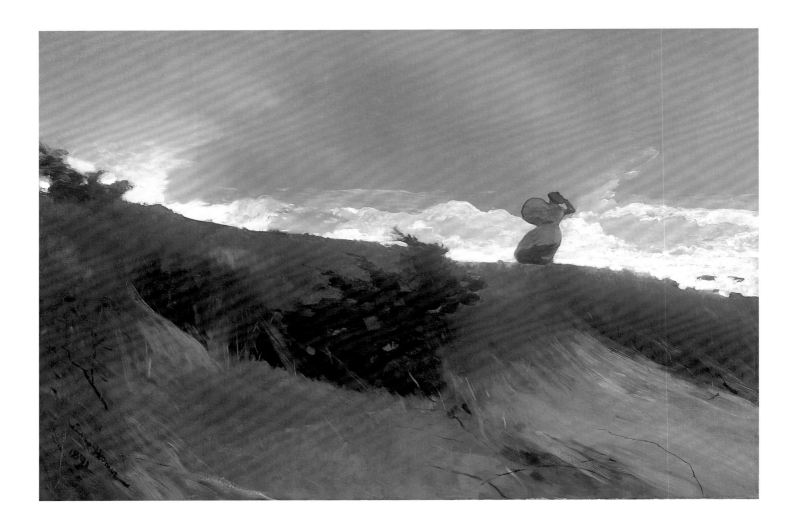

Winslow Homer *The West Wind*, 1891

blooming and honorable positive. He is also barbarously simple, and, to our eye, he is horribly ugly: but there is nevertheless something one likes about him.

33 Henry James, Jr., "On Some Pictures Lately Exhibited," *The Galaxy* 20 (July 1875): 93–94.

James concluded that Homer was a painter of great merit, who despite his "want of grace" could create "a very honest, and vivid, and manly piece of work."[33] For an artist like Winslow Homer, who supported himself throughout the 1870s as an illustrator for *Harper's Weekly*, James's criticism of his lack of pictorial features and intellectual detail seems misguided. Yet, it is perhaps an indication of Homer's independence from the artistic models of his time. Not for Homer were literary or historical allusions, delicacy of detailing, or cleverness—all attributes that James claimed for European artists such as the Spanish painter Mariano Fortuny, the Frenchman Jean-Léon Gérôme, and the Englishmen Edward Burne-Jones and Frederick Leighton, who were in favor at the time.

34 See Elizabeth Johns, *Winslow Homer: The Nature of Observation* (Berkeley: University of California Press, 2002), pp. 52–55.

Unlike many of his contemporaries, Homer did not study in the European academies. Thwarted by lack of financial backing and the conflicts of the Civil War, Homer was not able to travel to Europe until 1866. He spent eleven months in Paris and the surrounding countryside, painting, visiting with family, interacting with other artists, and presumably viewing works of art.[34] Even if he did not toil in the ateliers and schools under French masters, it is likely that he was exposed to contemporary French painting. Two of his paintings were included in the American section of the Paris Exposition Universelle in spring 1867; a visit to the Louvre was documented in a wood engraving made after his return. Returning with a newly acquired interest in a lightened palette, he renewed his determination to give up illustration in order to devote himself exclusively to painting.

It was after Homer's second trip across the ocean, this time to spend twenty months on the western coast of England, that the artist's mature style emerged. With his move to Prout's Neck, Maine, shortly after his return from the English seaside town of Cullercoats, both the subjects and compositions that Homer explored became bolder, more elemental. In 1886 he painted the majestic marine *Eight Bells*, which derives its power from the dramatic close-cropped composition and a vantage point that allows the viewer to join the two sailors on the ship's deck as the billowing clouds above barely part to allow a reading of the vessel's location. One critic of the time observed "the mingled grandeur and beauty of the sea" in Homer's paintings.

PLATE 17

35 Quoted in Johns, *Winslow Homer*, p. 121.

What makes his pictures of it all the more dramatic, illusive and stirring, is the fact that he opposes to its elemental vastness and heartless power the insignificant figures of men,— insignificant in strength, but dominating this terrible Titan by their brains and courage. This thrilling thought he illustrates as no painter has ever done before.[35]

PLATE 18

In *The West Wind*, painted five years after *Eight Bells* with a subtle palette of browns and grays, Homer sets a female figure at the edge of a tawny bluff, her back to the viewer as she holds her place against the rising wind and the spouting sea. In this masterful and minimal composition, the artist has held the silhouetted figure, wind-whipped vegetation, and whisper of foaming salt spray in an eternal equilibrium of human, land, and sea with an artistic power unmatched by his contemporaries, whether in Europe or America.[36]

In their discussions of paintings by Homer, both contemporary critics and later historians frequently identify the quality that makes his works distinctly American as masculine power. Critics in his own time commented on the "touch of the savage," the "epic strength," and the "masculine directness and force" in his work.[37] In the same review in which Henry James called Homer a painter of "perfect realism," with "a frank, absolute, sincere expression," he described a group of European paintings of "beflounced ladies tying their bonnet ribbons and warming their slipper toes" as "elaborately inane," even if they were painted "with extraordinary cleverness."[38] In a comparison that would persist well into the twentieth century and extend beyond Homer, American art became known as realistic and manly; European art as self-conscious, artificial, and feminine.

Thomas Eakins (1844–1916), the other acknowledged master of the late nineteenth century, can also be characterized as a painter of manly realism, though his work does not convey the powerful isolation of the human condition or classical monumentality of Homer's marines. Instead Eakins looked into the mind and soul of late nineteenth-century humanity, searching not for the individual courage of Homer's sailors, but for the transforming power of the intelligent mind.

While Homer and Eakins each made their first European trip in 1866, the goal of Eakins's travel, unlike that of Homer, was to train in the French academy. Enrolling in Gérôme's studio at the Ecole des Beaux-Arts, Eakins spent the next three years grappling with the lessons of French academic painting. He expressed admiration for Gérôme's sense of structure and clarity of color. He was also drawn to the spontaneity and freedom of Thomas Couture and the lush painterliness of Léon Bonnat, although he had not studied with either of them.[39] Leaving the Paris academy in 1869 without having completed his studies, he stopped in Spain on his way home, where he found painting by such masters as Velázquez "so strong, so reasonable, so free of every affectation. It stands out like nature itself."[40]

Upon his return to Philadelphia, Eakins worked to put to effective use the lessons of the academy and the compelling example of Velázquez and other Spanish painters. He first tackled a series of paintings of his family, all interiors, many

36 For further discussion of this work, see Susan Faxon, *Winslow Homer at the Addison* (Andover, MA: Addison Gallery of American Art, 1990); and Faxon, Berman, and Reynolds, *Addison Gallery of American Art*.

37 For further discussion of critics' responses, see Susan Faxon, "Man and Nature, Men and Women in the Addison's Homer Paintings," in *Winslow Homer at the Addison*, pp. 22–26.

38 Henry James Jr., "On Some Pictures Lately Exhibited," p. 92.

39 Henry Adams, *Eakins Revealed: The Secret Life of an American Artist* (New York: Oxford University Press, 2005), pp. 141–56.

40 Thomas Eakins to Benjamin Eakins, December 2, 1869, quoted in ibid., p. 158.

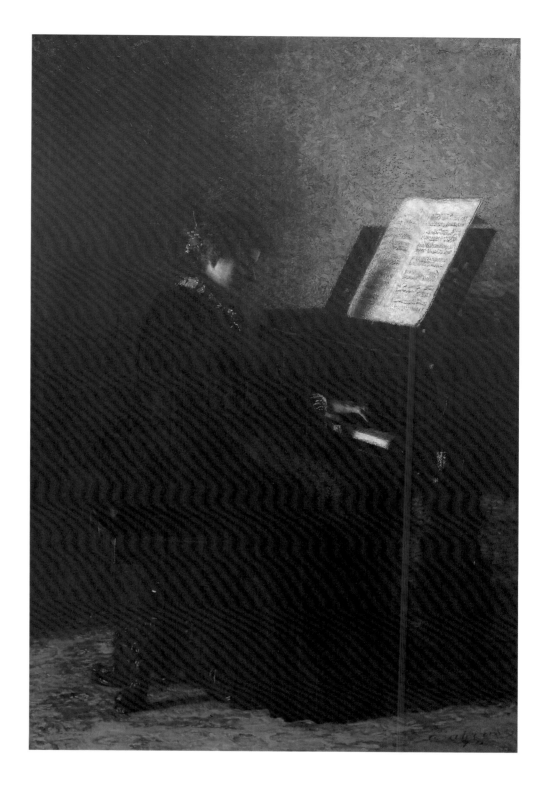

Thomas Eakins *Elizabeth at the Piano*, 1875

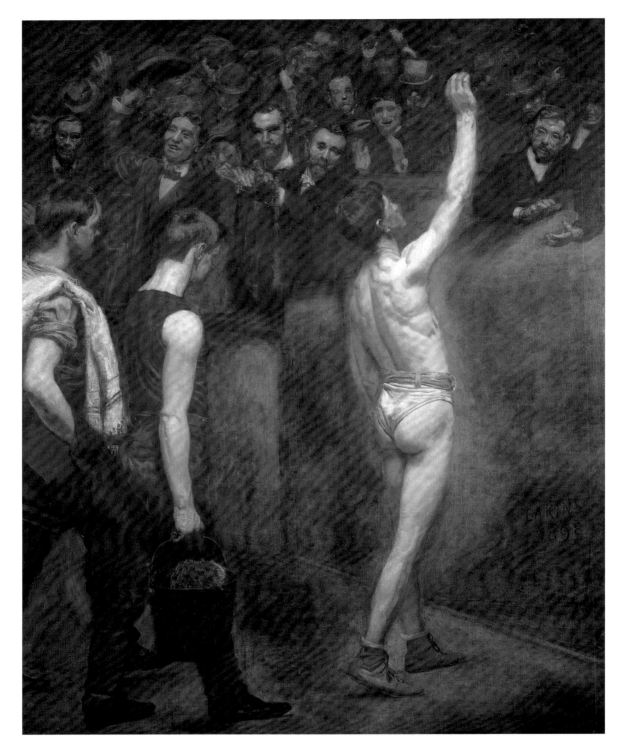

PLATE 20

Thomas Eakins *Salutat*, 1898

revolving around the playing of music. The last of this group was *Elizabeth at the Piano*, which art historian Henry Adams has claimed was "perhaps the most romantic painting of his career."[41] Merging the body of the figure, the piano and bench, and the shadowy background into dark indistinctness in the center of the painting, the artist uses light to focus attention on the most evocative aspects—the cheek of the pianist, the rose in her hair, her hand, and the keyboard. In this tribute to young womanhood and music, the woman, completely engrossed in the beauty of the music she is creating, is engulfed by a gray shimmer, perhaps of music itself, which rises in the air from the sheet in front of her.

In the same way that Homer was recognized for his disregard for the traditional standards of beauty, the critic Brownell correctly claimed that Eakins "is distinctly not enamored of beauty, unless it be considered, as very likely he would contend, that whatever is is beautiful."[42] In this characteristic, he can be aligned with American painters who had preceded him, such as Durand, Inness, and Lane, who embraced the specifics of reality as a tool for revealing an inner truth and strength, what Brownell called the "real truth—the essential, spiritual, vital force of nature.[43]

In another oil, *Salutat*, painted many years later, in 1898, Eakins turned to the male athlete and the rough and seedy male-only boxing arena. The delicate illumination that caught the figure's face and hand in the portrait of Elizabeth has been replaced by a glaring light that floods over the white flesh of the nearly nude boxer as he leaves the ring. The full title of the canvas, *Dextra Victrice: Conclamantes Salutat* (With his right hand the victor salutes those acclaiming him), pays direct homage to the paintings of gladiators by Eakins's Paris teacher, Gérôme.[44] Gone however are the high finish, the brilliant color, and the stilted construction of the European master. Gone, too, are the idealized setting, the typical classical figures, the stylized and formal poses. Here, Eakins portrays a known prizefighter in the lowly environment of a local Philadelphia boxing arena, surrounding him in his victory with the cheering and clapping of an enthusiastic and homely audience made up of recognizable members of Eakins's family and acquaintances. In this painting, Eakins reached back to a European model of his student days, absorbing, translating, and then transforming it into a distinctly American event, painted with a direct, relaxed technique that is an amalgamation of his European training and his American sensibility.

Eakins's absorption and transformation of European lessons to forge an Americanized expression was shared by the majority of artists in this country during the second half of the nineteenth century. At the same time, there was also a small group of Americans who reversed the process, moving across the ocean to participate in a European art world that they subsequently never left.

41 Adams, *Eakins Revealed*, p. 178.

42 Brownell, "The Younger Painters of America: First Paper," pp. 12–13.

43 Ibid.

44 Elizabeth Milroy, entry for *Salutat* in Faxon, Berman, and Reynolds, *Addison Gallery of American Art*, pp. 335–36.

PLATE 19

PLATE 20

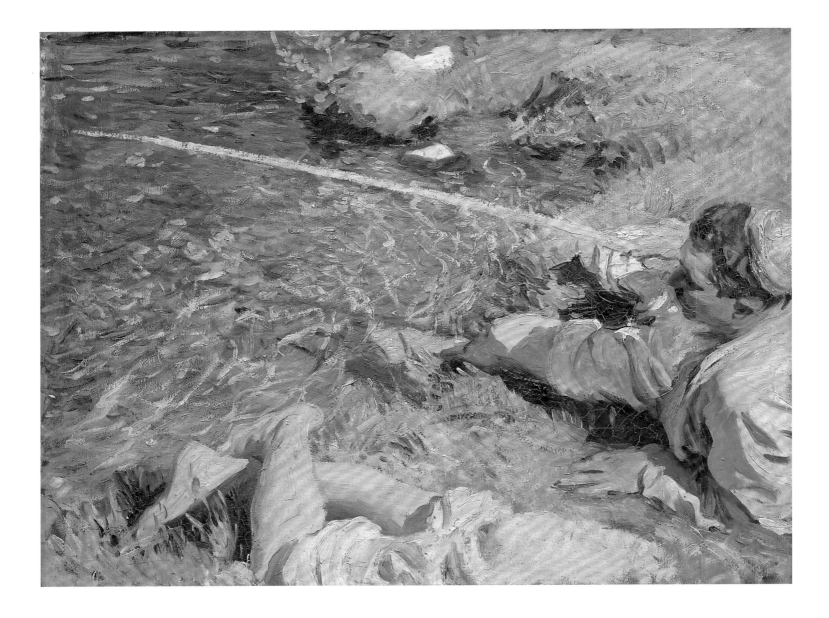

PLATE 21

John Singer Sargent *Val d'Aosta: A Man Fishing,* ca. 1906

John Singer Sargent (1856–1925) and Mary Cassatt (1844–1926) are two of the most well known of the group who spent their mature lives as expatriates. Cassatt became a member of the inner circle of avant-garde French painters, while Sargent traveled between London and Paris earning a reputation as a preeminent portraitist before turning later in his life to brilliant vignettes depicting leisure in the European countryside. Whereas Cassatt retained her identity as an American and painted French Impressionism with an American accent, Sargent was a cosmopolitan creature for whom being an American was a matter of birth rather than artistic predilection. His virtuoso natural skill, polished by technique learned in the Paris studio of Carolus-Duran and enhanced by the experience of his peripatetic expatriate life, made Sargent the perfect model for Americans whose aspirations brought them to Europe. He remained revered in America as well as England, both countries claiming him for their own. Sargent, born and raised in Europe, navigated international waters, only alighting in his native America at the end of his life. *Val d'Aosta: A Man Fishing*, painted in the Italian Alps, is a bravura example of Sargent's technical skill and his energized use of high-keyed color. The dramatic web of diagonals created by the cropped figures of the fishermen, the lazy fishing pole, and the water's edge is enlivened by the dashing impressionistic strokes of individual colors that give sparkle to the rippling water.[45] In this work, like the rest of his oeuvre, Sargent revealed himself as the consummate internationalist.

45 Trevor Fairbrother, entry for James Singer Sargent in ibid., pp. 460–61.

PLATE 21

No less bravura in both his personal and artistic style was another American expatriate, James McNeill Whistler (1834–1903). Unlike Sargent, Whistler, born in Lowell, Massachusetts, and educated at West Point, grew to maturity in America. Moving to Paris in 1855 to study painting, he never left, dying in London in 1903 after a flamboyant life in the art circles of that city. After his initial study in Paris and the success of his "French Set" of etchings, Whistler moved to London in 1859 to create etchings of the Thames. That same year, he received his first commission, to produce the painting *Brown and Silver: Old Battersea Bridge*, for a Greek magnate.[46]

46 Margaret F. MacDonald, entry for James Whistler in ibid., pp. 490–91.

PLATE 23

The extent of Whistler's adoption of European trends is evident in this picture, particularly when considering that the work was more or less contemporaneous with such major Hudson River paintings as Church's monumental *Heart of the Andes* (1859; The Metropolitan Museum of Art, New York). Even a comparison between *Old Battersea Bridge* and a smaller Church painting, *Mount Katahdin*, makes clear the different worlds and intentions of these two artists. Church chose to venture into the wilds of northern New England, capturing an untrammeled virgin terrain with meticulous attention to the seen landscape, perfectly controlled paint application, elegantly balanced color, and refined finish. In contrast to Church and others who sought to convey the transcendent character of landscape, Whistler had no such aim. Writing in *The Gentle Art of Making*

PLATE 22

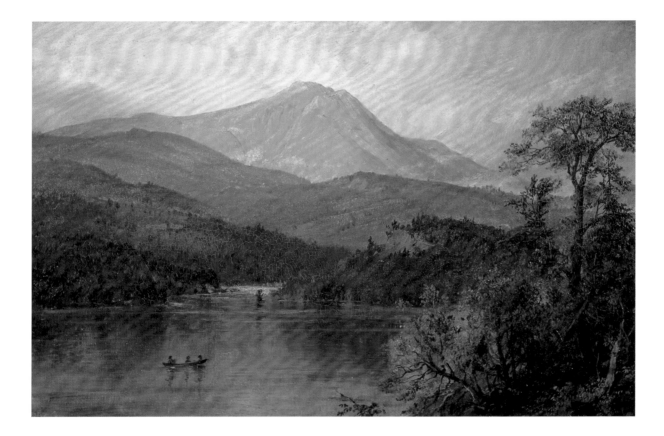

PLATE 22

Frederic E. Church *Mount Katahdin*, ca. 1856

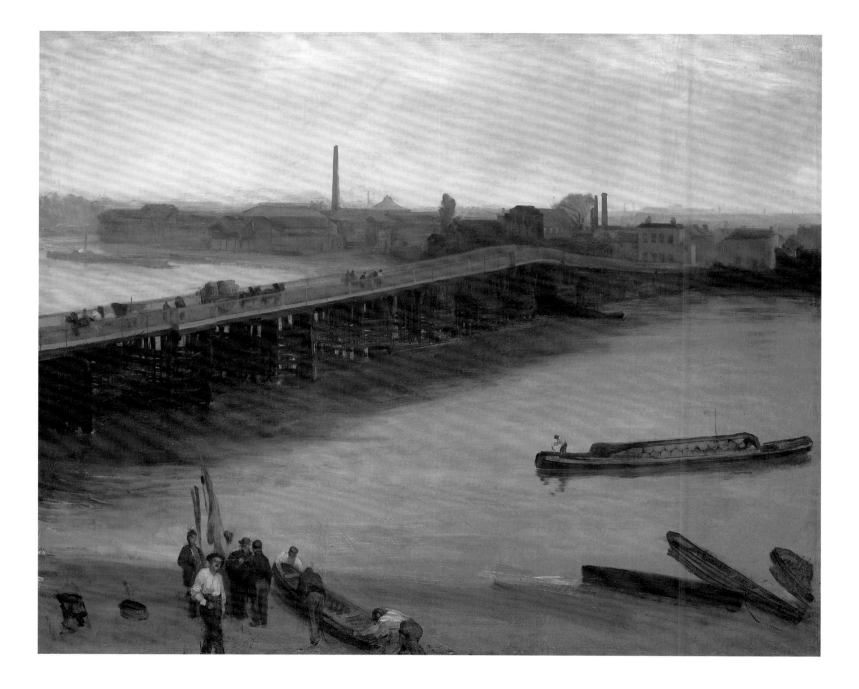

PLATE 23

James McNeill Whistler *Brown and Silver: Old Battersea Bridge*, 1859–63

Enemies in 1890, he described what he saw as the goal of painting: "[Art] should be independent of all clap-trap—should stand alone and appeal to the artistic sense of ear or eye, without confounding this with emotions entirely foreign to it, as devotions, pity, love, patriotism and the like."[47]

47 Quoted in Frances K. Pohl, *Framing America: A Social History of American Art* (New York: Thames and Hudson Inc., 2002), p. 270.

In contrast to Church's wilderness setting and jewel-like palette, *Old Battersea Bridge*, painted almost totally in a palette of grays and browns, is set squarely in the heart of an urban environment. The water's edge, the bridge, and the skyline of buildings on the opposite shore are not players in a Whistlerian narrative. Rather they are elemental shapes balanced across a controlled and abstracted composition. Spatial depth is restricted, as the foreground, bridge, and distant shore are knit together into a Z-shape that dominates the canvas, an obvious reference to the asymmetrical structure of the Japanese prints Whistler would have seen in London. The evidence of Whistler's integration of European tastes and styles becomes even more pronounced when *Old Battersea Bridge* is examined in conjunction with Homer's *The West Wind*. Although they feature similar diagonal compositions and reduced palettes, the two paintings provide a vivid contrast between the energized and aggressive American realism of Homer and the elegant, even ethereal European sensibilities of Whistler.

Whistler's affinity for Japanese prints and close color harmonies, his insistence on the formal quality of a work, the emphasis on decorative, flattened surfaces, and the rejection of sentimentality and narrative were all characteristics of the Aesthetic movement of the 1870s and 1880s in Europe. Building on Ruskin's ideas, which championed an integration of arts and manufacture, the Aesthetic movement encouraged a broader definition of artistic endeavors that included mural painting, architectural decoration, and interior design and offered artists and clients a more expansive menu of influences, from the Japanese to the Moorish, to the classical.

These ideas were brought to the vivid attention of Americans in the displays at the 1876 Centennial Exposition. A number of artists found interest in the wider range of aesthetic models that were revealed in this lavish display of international arts and industry. Exposure to European examples of Aestheticism encouraged American artists to experiment in new media and styles and further broke the hold of the moralizing purpose of painting, allowing design, composition, painterliness—art for art's sake—to inform American painting. Artists were given confidence, in the words of art historian Doreen Bolger Burke, "to consider formal qualities—line, color, and shape that then assumed new prominence in the work they produced."[48]

48 Doreen Bolger Burke, "Painters and Sculptors in a Decorative Age," in *In Pursuit of Beauty: Americans and the Aesthetic Movement* (New York: The Metropolitan Museum of Art, 1986), p. 335.

Assured by their rigorous academic training in the French academies, American artists of the 1880s and 1890s applied their technical abilities to a wide range of subjects. One group of artists turned to a vocabulary drawn from the Italian Renais-

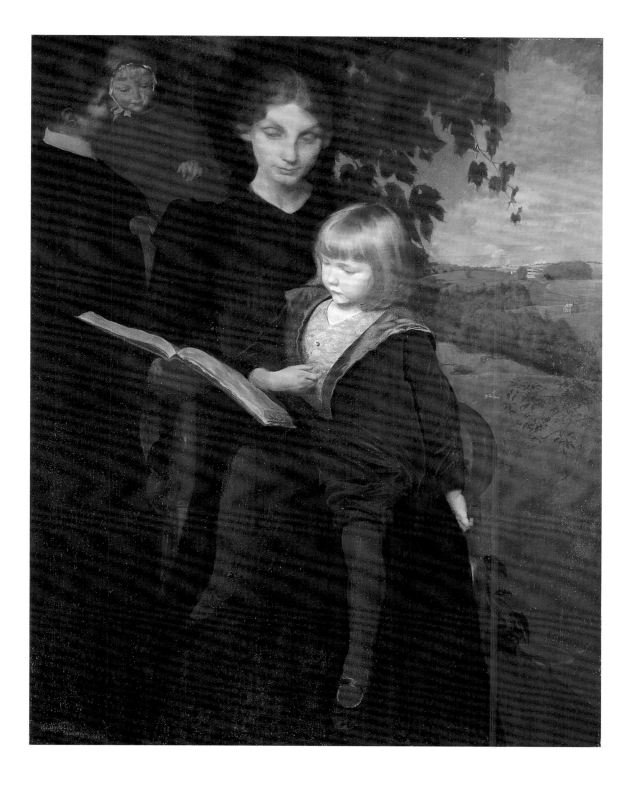

PLATE 24

George de Forest Brush *Mother and Child*, 1892

PLATE 25

Augustus Saint-Gaudens *The Puritan*, after 1886, cast 1899

PLATE 26

Thomas Wilmer Dewing *Reverie,* before 1928

PLATE 24

PLATE 25

sance to create classicized and idealized images of women. Abbott Thayer, Thomas Dewing (1851–1938), Augustus Saint-Gaudens (1848–1907), and George de Forest Brush (1855–1944), all of whom had met during their studies in Paris in the 1870s and settled in New York thereafter, saw themselves as forging a new American expression, one that linked them to the great traditions of the artistic past. Brush's *Mother and Child* is a prime example of this impulse. Like his colleague Abbott Thayer, who often transformed his children and neighbors into idealized visions of angels and virginal young women, Brush enlisted his own family to sit for this work. The artist tenderly portrays his wife Mittie holding their son Gerome, named for the painter's teacher in France. Behind on the left, a nursemaid holds their daughter, while on the right the view opens onto a pastoral landscape in which sits Saint-Gaudens's Cornish, New Hampshire, house where Brush painted the work. In spite of the numerous personal and recognizable elements, the subject of the painting is, in fact, a Renaissance-inspired Madonna and Child. Realism and idealism merge in this mysterious and haunting canvas, informed by French painterly lessons and imbued with lofty ambitions for the American artist.

Saint-Gaudens, arguably American's greatest nineteenth-century sculptor, likewise melded realism, idealism, superior technical skill, and a reverence for Western European artistic traditions into a particularly American statement in his bronze *The Puritan*. Instead of Renaissance subject matter, however, the work commemorates a significant moment in America's historical past. A smaller and later version of the artist's monumental sculpture commissioned to represent one of the early founders of the Massachusetts Colony and designed to stand in a public park in Springfield, Massachusetts, it is refined yet energized, with parts integrated into a flowing totality. *The Puritan* is testament to Saint-Gauden's ability to infuse his work with "the vitality of restrained emotion, strength with style, and elegance of expression."[49]

Contemporary with Brush and Saint-Gaudens were American artists who alternately found inspiration in the fresh and revolutionary work of the French Impressionists. American students in Paris, who came to learn the lessons of the old masters and the academic tradition, participated in a moment in French art history in which traditional bounds were being challenged. The plein-air painting experienced in the Barbizon region and on traditional summer trips into the countryside had nurtured the growing appreciation of painterly freedom in American and French students alike. Now a new generation of French artists—dismissively dubbed the Impressionists—was rejecting the finish of academic painting, relishing instead the fluidity of paint, the brilliance of color, and effects of light in their adventurous works. Although many American students found this new expression as discomforting as did their

49 John Dryfhout, "Augustus Saint-Gaudens," in *Augustus Saint-Gaudens, 1848–1907: A Master of American Sculpture* (Toulouse, France: Musée des Augustins, 1999), p. 9.

PLATE 27

John Twachtman *Hemlock Pool*, ca. 1900

French compatriots, as the century progressed, they found their own expression in a version of this style.

PLATE 28

Theodore Robinson (1852–1896) was among a number of American artists who traveled to Giverny, the village where the French Impressionist painter Claude Monet had settled. During his stay in Giverny, from 1887 to 1892, Robinson developed a close personal and artistic relationship with Monet. *Valley of the Seine* is an indication of the profound influence of Monet on the American, but it is also a revelation of the particular ways in which American artists adopted and interpreted French Impressionism in their work. Like Monet's Rouen Cathedral series, Robinson's painting is one of three, each of the same scene, each painted at a different time of day. While the emphasis on the shifting effects of light is similar to paintings by Monet, the more muted palette, the strong geometric structure of the composition, and the retention of fidelity to the actual are all characteristics of Robinson's work, and indeed of much of what became known as American Impressionism. Robinson's attachment to his academic training, his early years working in the Barbizon landscape, and, as was true for many of his compatriots, his American tendency toward a faithfulness to the real all keep *Valley of the Seine* tied to place and moment, even as the artist's enchantment with the shifting light and pale greens and blues reveals his debt to the French painters of light and color.[50]

PLATE 27

John Twachtman's *Hemlock Pool* best exemplifies the skill and mastery with which American Impressionists incorporated the lessons of Impressionism into their work at the turn of the century. A lyrical poem of close tones, abstract design, and broken color and brushstroke, this painting represents Twachtman's accomplished integration of Impressionist technique with the harmonies and tones of Whistler and Aestheticism, structural models of Japanese art, and a personal expression of the spiritual solace of nature, masterfully applied to a wooded fragment of Connecticut landscape.

Overdue recognition of the contribution that American Impressionism made to the turn-of-the-century artistic climate can find footing in paintings such as *Hemlock Pool*. European lessons were merged with the American love of landscape, transformed by a personalized adoption of the best of each. This was not French Impressionism transported; rather it was a transformation of European influences into a new American expression.

While American Impressionists were capturing dappled woodland moments, leisure-class respites in flower-filled urban parks, or the heat of seaside vacation spots on canvases that were paeans of light and color, others were turning their attention to the face of American urban life. *Early Morning on the Avenue in May 1917* by Childe Hassam

PLATE 29

50 Sarah Vure, entry for *Valley of the Seine* in Faxon, Berman, and Reynolds, *Addison Gallery of American Art*, pp. 456–57.

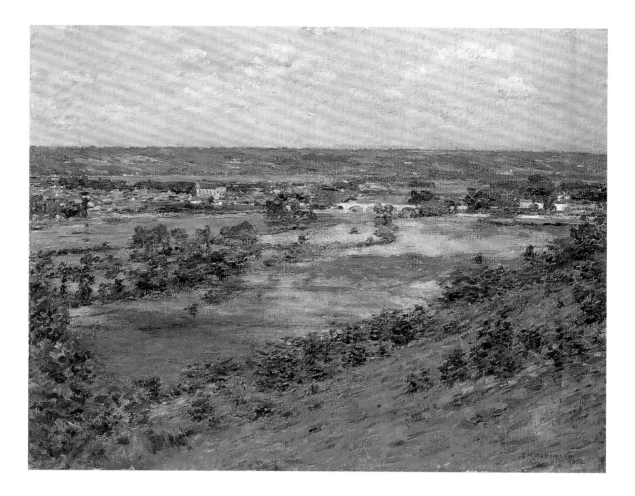

PLATE 28

Theodore Robinson *Valley of the Seine*, 1892

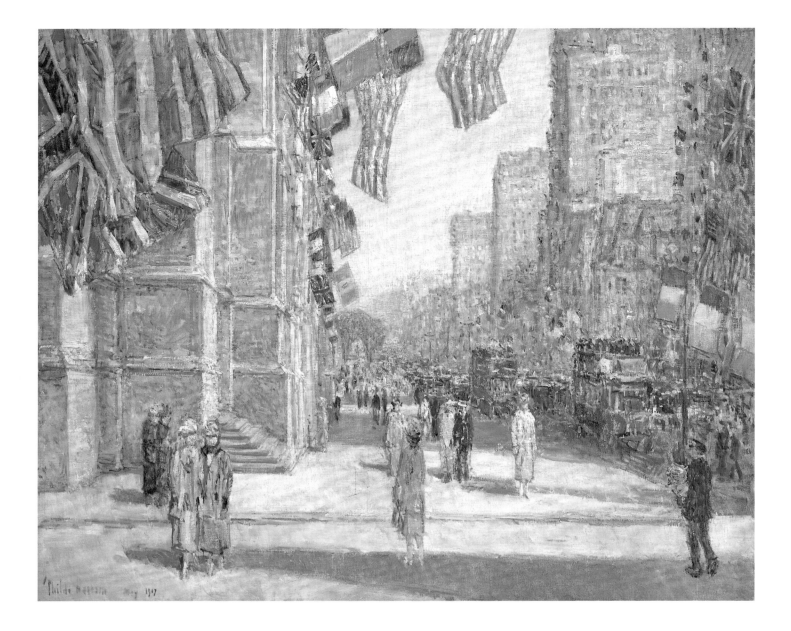

Childe Hassam *Early Morning on the Avenue in May 1917*, 1917

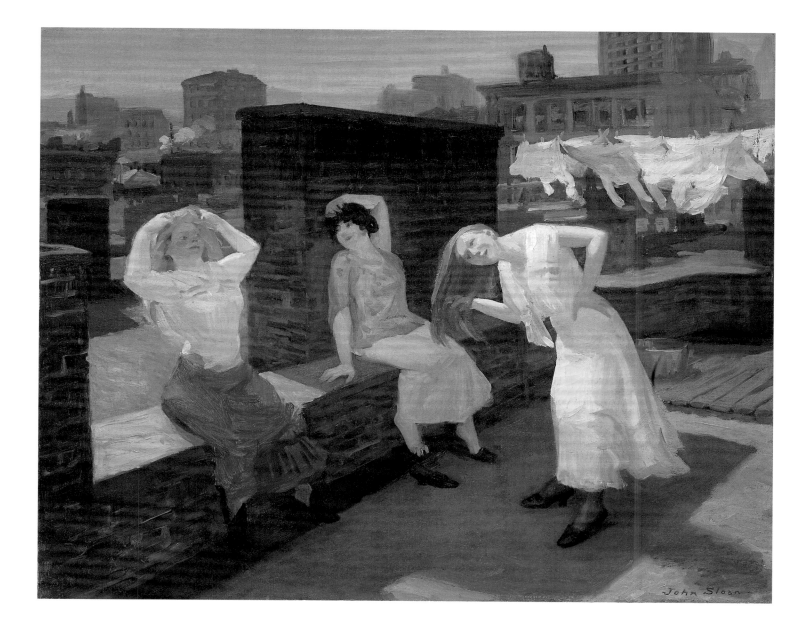

PLATE 30

John Sloan *Sunday, Women Drying Their Hair*, 1912

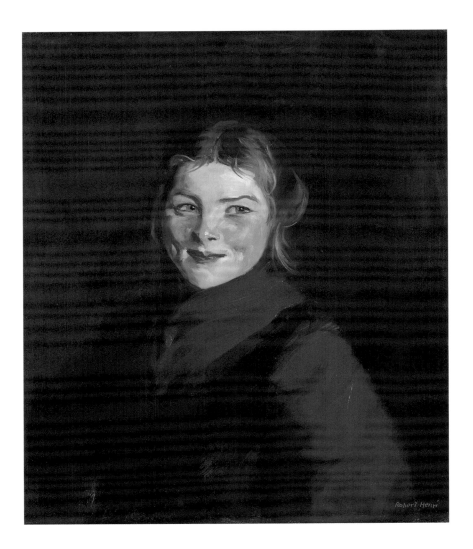

PLATE 31

Robert Henri *Mary,* 1913

George Luks *The Little Madonna*, ca. 1907

PLATE 30

(1859–1935) and *Sunday, Women Drying Their Hair* by John Sloan (1871–1951) of five years earlier offer an instructive comparison of impulses in American art that were occurring simultaneously. They also highlight societal rifts focused on status and elitism, lives of leisure and work, urban versus rural, native-born and immigrant—all transforming factors in the development of early twentieth-century America.

Hassam's painting is rich with references to privilege and patriotism. Memorializing a parade down New York City's posh Fifth Avenue to heighten support for the Allied cause during World War I, Hassam delighted in the bright midday light, the fashionably dressed ladies in white, the dizzying flutter of flags, the tall omnibuses as they inched down the avenue. Hassam has applied the impressionistic technique he had adopted two decades earlier to this painting, a tour de force of vivid color, sparkling light, and eager patriotic spirit. Sloan's canvas offers a dramatic shift of theme and tone. While it also depicts a moment of leisure, this moment is far more restricted—this is Sunday, the day of rest for those compelled to work. Fashionable Fifth Avenue matrons, barely suggested in quick brushstrokes by Hassam, are replaced by solid three-dimensional women on the rooftop of a tenement reveling in simple pleasures of time off and easy companionship.

Mirroring the informative contrasts of subject and technique, the artists' biographies illustrate the dramatic shift in acceptable training available to the American painter of the turn of the century. While Hassam developed his methods in the French atelier and galleries, Sloan gained his training at the Pennsylvania Academy of the Fine Arts in Philadelphia, one of a number of American art schools that provided a reliable alternative to the requisite European study of earlier artists. By this time, even an artist like Saint-Gaudens, who had undertaken traditional studies in France, could write to a young student, "I am convinced that as thorough and adequate training can be had here as abroad, that the work by the students here is equal to that produced by those in Europe."[51]

51 Homer Saint-Gaudens, ed., *The Reminiscences of Augustus Saint-Gaudens*, vol. 2 (New York: The Century Co., 1908), p. 39.

PLATE 31

Among Sloan's instructors at the Pennsylvania Academy was the charismatic teacher and artist Robert Henri (1865–1929), who himself had traveled and studied extensively in Europe. In Henri's hands, Sloan, fellow students George Luks (1867–1933), Everett Shinn (1876–1953), William Glackens (1870–1938), and the younger George Bellows (1882–1925) were introduced to the painterly styles of artists who had strongly influenced their instructor—Rembrandt, Hals, Velázquez, Manet, and Whistler. These influences are clearly evident in Henri's *Mary*, a dazzling portrait of a young Irish girl whose rosy cheeks and sparkling eyes are suggested by full glowing color and fluid strokes. Through Henri's example, Sloan and others turned not to the broken brushwork and bright light of the Impressionists, but to the exuberant paint application and richer to-

52 Robert Henri, *The Art Spirit* (1923; reprinted New York: Harper & Row, 1984), p. 129.

53 Ibid., p. 116.

54 H. Barbara Weinberg, Doreen Bolger, and David Park Curry, *American Impressionism and Realism: The Painting of Modern Life, 1885–1915* (New York: The Metropolitan Museum of Art, 1994), p. 8.

55 John Wilmerding, "The Art of George Bellows and the Energies of Modern America," in Michael Quick, *The Paintings of George Bellows* (Fort Worth, TX: Amon Carter Museum, 1992), p. 1.

56 Allison Kemmerer, entry for *The Circus* in Faxon, Berman, and Reynolds, *Addison Gallery of American Art*, p. 323; see also Michael Quick, "Technique and Theory: The Evolution of George Bellows's Painting Style," in *The Paintings of George Bellows*, pp. 38–41.

nalities of the older masters. Their subject matter shifted as well. Claiming that "a good picture is a fruit of all your great living,"[52] Henri called for artists to look for common experiences.

Painting is the expression of ideas in their permanent form. It is the giving of evidence. It is the study of our lives, our environment. The American who is useful as an artist is one who studies his own life and records his experiences; in this way he gives evidence.[53]

The early work by Sloan and Luks as newspaper illustrators, as well as the admiration these artists shared with Henri for the bravura gestural character of Homer's painterliness and Eakins's frank and direct subject matter, turned their eyes to urban life at the street level and encouraged a fluid quickness of technique. In Luks's *The Little Madonna*, a young girl sitting on an alley curb pulls her oversized doll to her for a kiss as a mysterious kerchiefed woman crouches in the background. Elements of humor—the concept of the child and doll mimicking the classical pose of Madonna and Child—balance with a clear-eyed appraisal of the dangers of street life, all tempered by sympathetic appreciation of a touching human moment. However gritty the setting, or common the protagonist, Luks and Sloan, as well as Henri, imbued their canvases with an optimistic appreciation for the nobility of the common person.[54]

PLATE 32

Under the tutelage of Henri in New York, where the older artist had taken over the classes of William Merritt Chase at the New York School of Art, George Bellows honed what art historian John Wilmerding has called his "vigorous style, full of physicality and personal energy."[55] In the same year that Sloan painted young women on a Sunday morning, and several years before Hassam created his impressionistic Fifth Avenue, Bellows ventured into the New Jersey countryside to capture the high-spirited moments of a regional circus performance. He filled his painting *The Circus* with the excitement and movement of the popular entertainment. With energized brushwork he highlighted the brilliance of the central ring in bright whites that stand out against the surrounding taupes and moss greens, the spontaneity of the application belying the deliberate internal structure of the work.

PLATE 33

Bellows had discovered Jay Hambidge's theories of dynamic symmetry and, through Henri, had been introduced to the compositional system of Hardesty G. Maratta, which was based on the equilateral triangle and mathematical proportions that he claimed were found in nature, ancient art and architecture, and Renaissance paintings.[56] Applying the Maratta system, Bellows punched a grid of pinpricks into the canvas of *The Circus* in order to provide an overall geometric structure of diagonals and triangles over which to compose the painting. The resulting composition thus integrated an animated and familiar event of everyday life with a technique adopted from the

George Bellows *The Circus*, 1912

example of Europe's great masters, which was then translated through fresh, buoyant brushstrokes, underscored by unswerving structure and order. Here then is a quintessentially American painting of the modern American experience that acknowledged the contributions of history but was not constrained by them. Some years later, Bellows explained,

> *There is no new thing proposed, relating to my art as a painter of easel pictures, that I will not consider…. I have no desire to destroy the past, as some are wrongly inclined to believe. I am deeply moved by the great works of former times, but I refuse to be limited by them. Convention is a very shallow thing. I am perfectly willing to override it, if by so doing I am driving at the possibility of a hidden truth.*[57]

57 "The Relation of Painting to Architecture: An Interview with George Bellows, N. A., in Which Certain Characteristics of the Truly Original Artist Are Shown to Have a Vital Relation to the Architect and His Profession," *American Architect* 118 (December 29, 1920), p. 848.

It is this last line that perhaps most perfectly captures what American art since the mid-nineteenth century had been seeking to express.

PLATE 34

Stuart Davis *Red Cart*, 1932

WILLIAM C. AGEE

American Art, 1910–1950s: Themes, Traditions, Continuities

AMERICAN ART EVOLVED GRADUALLY over the course of the eighteenth and nineteenth centuries, but beginning in 1908 it entered a forty-year period of accelerated and remarkable maturation. While in that year America still lagged behind modernism in Europe, by 1914 it had become a significant center of modern art. Three crucial events that occurred in 1908 marked the start of this development. The prestige of the artist Robert Henri as a teacher was at its height, and his championing of a direct, unmediated approach to art and life, which came to be known as Realism, quickly spread through an entire generation of emerging artists, Stuart Davis and Edward Hopper among them. Henri also organized a benchmark exhibition of the work of eight realist-oriented artists, who became known as The Eight. This exhibition, coupled with his teaching, announced a break with the old academic institutional hold on American art, replacing it with a modernist approach. In addition, in Paris in that same year, Henri Matisse, the giant of European modernism, opened his own school, at the behest of the Americans Max Weber and Patrick Henry Bruce, as well as the collectors and patrons Sarah and Michael Stein. Teaching that color was the means to an independent structural and expressive method of making art, Matisse and his school had profound effects on American art for the next sixty years. Finally, back in New York, the master photographer Alfred Stieglitz, who had come to understand that modernism entailed an entire approach to making art by "working out of the materials," as he termed it, initiated, in

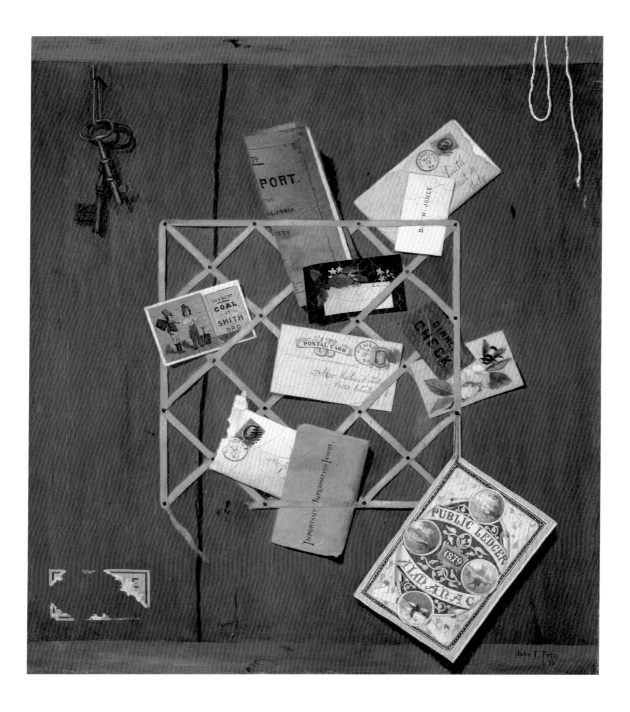

John F. Peto *Office Board for Smith Brothers Coal Company,* 1879

1908, a series of exhibitions at his gallery 291 that began the education of Americans in the methods of modern art.

The Stieglitz series of exhibitions can been seen as culminating in the Armory Show of 1913, a massive exhibition that almost overnight brought America up to date in the latest developments in modern art. Here Americans could learn about Cubism, fauvism, color abstraction, Expressionism, and other modernist developments. Its impact on countless Americans was swift and decisive, spreading through the study of paintings acquired from this exhibition, paintings that would form the basis of new and important collections. Stieglitz himself bought several key works that were then shown at his gallery and from which generations of American artists could learn. Among them were Picasso's 1910 charcoal drawing of a standing woman (now in the Metropolitan Museum of Art), which to this day provides perhaps the single most revealing and instructive lesson about the essentials of Cubism. From the events of 1908 and the Armory Show in 1913 emerged many of the basic structural, expressive, and technical approaches to America's modern art during the first half of the twentieth century. These approaches were numerous and complex, but among the most important, all well represented in the Addison's collection, were realism, color, cubism, classicism, and the use of new materials and techniques.

REALISM AND THE SEARCH FOR THE REAL

One of the most venerable and still most noted continuities within American art has been its persistent strain of realism. Proponents of realism, as defined by precision of drawing and figuration, included, in the eighteenth and nineteenth centuries, John Singleton Copley, John F. Peto, William M. Harnett, Winslow Homer, and Thomas Eakins, and in the twentieth century, Edward Hopper, Charles Sheeler, and Louis Lozowick. Realism of subject matter defined the art of early twentieth-century American artists such as Robert Henri, George Bellows, John Sloan, and later, Edward Hopper, and was a breakthrough for the very conception of what art in this country could be. Realism, in this sense, however, only touches the surface of what this complex term has meant to modern American art. In fact, the realist tradition has extended into the twentieth century in ways that are less apparent but no less important.

One might say that modern American realism began with a focus on the reality of perception, the immediacy of the viewer's engagement with the paintings and their effect on the viewer. This stems from the modern artist's desire to engage the viewer as directly as possible, through an unmediated experience of the painting, by removing all visual or narrative elements between the artist and painting, and between the viewer and the painting. We can thus feel the reality of the painting itself as an independent

object, not so much as a picture of something, but rather as something in its own right, obeying its own laws and dictates. We can feel this in the materials themselves—the paint, its weight, textures, touch, and density, a palpable material presence that can be traced to the howling gale in Homer's _The West Wind_, and extended to Jackson Pollock's _Phosphorescence_, the latter a radically abstract painting that nevertheless makes reference to a natural phenomenon occurring in the Long Island landscape where the artist lived and worked. It is as if Pollock's painting becomes a piece of that landscape itself.

PLATE 18

PLATE 59

Modern American artists sought to capture the physical, felt reality of the world around them, indeed, the substance of life itself. American art thus can be said to have evolved from _realism_ into a search for _the real_. The American painter and critic Fairfield Porter, writing in the 1960s, pointed out that there is less difference between a realist painting and an abstract work than we have been conditioned to assume: "The realist thinks he knows ahead of time what reality is, and the abstract artist what art is, but it is in its formality that realist art excels, and the best abstract art communicates an overwhelming sense of reality."[1] In his 1935 painting _Autumn_, Arthur Dove etched organic forms, concrete shapes, to embody the feel, the textures, something "real," as he termed it, of the movement of the natural world around him, a drive that would lead his friend Georgia O'Keeffe to refer to him as an artist who worked as if "of the earth."[2] Conversely, Hans Hofmann, in his essay "The Search for the Real in the Visual Arts"—published on the occasion of a solo exhibition at the Addison Gallery in 1948—insisted on the multiple physical properties of a painting as its essential, material core, creating a bridge to the ultimate reality of art, the spiritual plane.

PLATE 36

Moreover, the urge for an ever more real, and physical, art would lead a generation of American sculptors, notably Alexander Calder and David Smith, to move from the flatness of painting into three dimensions, into the viewer's space, to transform the inherent illusionism of painting into an art of the tangible and the concrete. It set the stage for later art as well, for the large-scale "specific objects" of Donald Judd and Minimalism, followed by the Earth Art projects of Robert Smithson, Walter De Maria, and James Turrell, artists whose expansive ambition embraced the vast western landscape itself, so that their artworks became part of the land, the same land depicted by many American artists of the nineteenth century. This drive to reality in the arts did not stop there. More recently, it has been translated into sprawling multimedia installations that can include film, video, and found and constructed objects of all sorts, perhaps reaching its ultimate early twenty-first–century form with reality television, in which there is no difference between art and life.

Realism of subject matter, so important to an emerging American modernism,

1 Fairfield Porter, "Art and Knowledge" (1966), reprinted in _Art in Its Own Terms, Selected Criticism, 1935–1975_, ed. Rackstraw Downes (New York: Taplinger Press, 1979), p. 259.

2 Georgia O'Keeffe quoted in William C. Agee, "Arthur Dove: A Place to Find Things," in Sarah Greenough et. al., _Modern Art and America: Alfred Stieglitz and His New York Galleries_ (Washington, D.C.: National Gallery of Art, 2001), pp. 421–39.

Donald Judd
To Susan Buckwalter, 1965
Blue lacquer on aluminum and galvanized iron, 30 x 141 x 30 inches
Edition 3/3
Addison Gallery of American Art, Phillips Academy, Andover, Massachusetts; gift of Frank Stella (PA 1954) (1993.45)

PLATE 36

Arthur Dove *Autumn*, 1935

PLATE 37

William Baziotes *Three Forms*, 1946

Adolph Gottlieb *Untitled,* ca. 1953

originated in contemporary urban life, finding expression in such early twentieth-century works as the lively portraits of Henri, the spectacle of Bellows's circus scenes, or Sloan's portrayal of three women drying their hair—paintings that all capture the pace and texture of the city, as did the later work of Jacob Lawrence, such as _Kibitzers_. That

PLATE 3

tradition of urban realism continued even in a much later painting, _East Broadway_ of

PLATE 46

1958, an early abstraction by Frank Stella. Here the black bands and dirty yellow field embody the dim, filtered light and steel structures of the Lower East Side of New York. The work has the feel and mood, and texture, of the inner city, similar to what was con-

PLATE 20

veyed in Eakins's much earlier _Salutat_, which with its dark palette explored the stark interior setting of a lowly boxing arena. That American artists have looked so often to the immediate and real world around them places them in the midst of a continuing, modern question and quest that can be termed the "art and life" issue, which has as its fundamental concerns the sources and purposes of art: Where should art come from? What should be its subject? Or does it even have a subject? To whom should it be addressed? Although it absorbed the modernists, this issue had its roots in mid-nineteenth-century France, at a time when art had all but been cut loose from its traditional sources of royal and religious patronage. It was symbolized by two ranking artists of the day: Ingres, who saw art as something fantastic, exotic, distant from the everyday world, and Courbet, who insisted on an uncompromising realism, an art that focused on the most immediate and pressing personal and political concerns of the moment.

This dichotomy extended deep into the twentieth century and took many forms. Although abstract, William Baziotes's _Three Forms_ of 1946 and Adolph Gottlieb's

PLATE 37

Untitled of around 1953 both merge references to ancient primitive cultures and cosmic

PLATE 38

events through a deeply personal handwriting by which the artists seek to connect with the vital impulses of the world and with psychic impulses of the unconscious. At another extreme, Ad Reinhardt, whose _Abstract Painting, Red_ of 1952 offers an alternative,

PLATE 39

geometric style, insisted that art should make no such references, that it is by nature purely self-referential and self-sufficient. He famously summarized this approach when he wrote in 1962 in "Art-as-Art": "The one thing to say about art is that it is one thing. Art is art-as-art and everything else is everything else. Art-as-art is nothing but art. Art is not what is not art. The one object of fifty years is to present art-as-art and as nothing else…making it purer and emptier, more absolute and more exclusive."[3]

Given their long attachment to the land, modern American artists have often adopted abstract pictorial means to capture the reality of their immediate environment, as did O'Keeffe in _Wave, Night_ of 1928, or as Hopper did in _Manhattan Bridge Loop_ of the

PLATES 42, 53

same year, the latter painting conveying the feel and pulse of the city in an ostensibly realist manner that nonetheless makes use of abstract forms. Yet while the debate

3 Ad Reinhardt, "Art-as-Art," _Art International_ 6, no. 10 (December 20, 1962); reprinted in _American Artists on Art from 1940 to 1960_, ed. Ellen Johnson (New York: Harper and Row, 1982), p. 31.

PLATE 39

Ad Reinhardt *Abstract Painting, Red,* 1952

Milton Avery *Sea Gulls—Gaspé*, 1938

4 Mark Rothko and Adolph Gottlieb, letter to the editor, *New York Times*, quoted in Edward Alden Jewell, "'Global-ism' Pops into View," *New York Times*, Sunday, June 13, 1943; reprinted in Johnson, ed., *American Artists on Art from 1940 to 1960*, pp. 13–14.

between realism and abstraction went on, it becomes clear that each mode had its own subjects and meanings, for as Mark Rothko and Adolph Gottlieb wrote in 1943, the idea that there is good painting about nothing is the essence of academicism.[4] In the purist works created in the 1940s by Josef Albers, Burgoyne Diller, and Charmion von Wiegand, for example, all artists who apparently insisted on a fully self-referential art, there is a meaning and a subject matter, if we only learn to read the language of abstract geometric art. In these works—which trace their lineage to Mondrian, De Stijl, and the Bauhaus, all born from the mass chaos and destruction of World War I—we can see diverse ways of creating pictorial metaphors for the staccato movements and vertical thrusts of the city, the here and now, fused in harmony and equilibrium, which at the same time proposes models for a personal and inner harmony as well as world peace and stability.

5 See, for example, David Batchelor, "Chromophobia, Ancient and Modern, and a Few Notable Exceptions," in *Art and Design* (July/August 1997): 31–32; and his book *Chromophobia* (London: Reaction Books Ltd., 2000).

6 The literature on color is extensive. A good overview can be found in John Gage, *Color and Culture/Practice and Meaning from Antiquity to Abstraction* (Berkeley: University of California Press, 1993).

COLOR

Color has been crucial in shaping the structure and creating the mood of modern art, and it is in itself a key agent in constructing a painting. We think less of color and give it less attention than line and drawing—the clear, sharp linear precision of John Singleton Copley or Charles Sheeler, for example—because we mistakenly think of color as decorative in the pejorative sense, less serious or complex than line. This is a longstanding prejudice, dating to the Renaissance, a period that held Florentine *disegno* to be superior to Venetian *colore*.[5] But color is just as complex and just as profound, both formally and emotively, for it can often be the subject of the painting itself while affecting us at our

John Singleton Copley
Mary Elizabeth Martin, 1771
Oil on canvas, 44 3/4 x 39 inches
Addison Gallery of American Art, Phillips Academy, Andover, Massachusetts; museum purchase (1942.32)

deepest emotive levels. As an independent element, freed from its old role as a supporting agent to linear shaping, color has been fundamental to the development of modern art, especially abstract painting.

Color has a long history, of course,[6] but its emergence as a full-blown expressive and structural force dates to Impressionism in the 1860s and later, a tradition exemplified by John Twachtman's *Hemlock Pool* of about 1900 and Childe Hassam's *Early Morning on the Avenue May 1917*. These paintings, both made late during the artists' careers, testify to how strong Impressionism remained well into the twentieth century, a tendency most notable in the late work of Claude Monet and Auguste Renoir, both of whom lived well into the twentieth century, but equally evident in the American art of the second decade of the twentieth century.

PLATE 27
PLATE 29

The effects of Impressionist color did not necessarily end with the 1920s. The allover gray-blue veils of atmospheric color that characterize the work of Twachtman and Hassam seem to infuse the surface of Milton Avery's painting *Sea Gulls–Gaspé* of 1938. One of America's greatest colorists, Avery often has been referred to as the

PLATE 40

"American Matisse," an accurate enough reference but far too narrow to cover the full range of the American's color interests. Born in 1885, Avery studied art during the peak of late Impressionism and was clearly influenced by Twachtman early on in his training. He would have been well aware of Hassam, one of America's most famous artists, then and now. Avery also assimilated the soft, chalky colors of Maurice Prendergast—a key if still less recognized figure in the emergence of modernism in America—as in his

PLATE 65

painting of around 1914–15, _The Swans_. While Avery pushed color to new expressive heights, he can also be seen as a bridge figure, connecting the earlier generation with younger artists such as Mark Rothko and Adolph Gottlieb, whom Avery befriended and mentored in the formative stages of their careers. The lessons of color possibilities instilled by Avery are evident in the bold hues and powerful contrasts of black, red, and white of Gottlieb's _Untitled_. In fact, Avery's early use of color to cover the entire picture surface may well be said to presage the development of a full chromatic abstraction, known as color field painting, after 1950.

When we think of color, we almost always associate it exclusively with the bright, high-keyed hues of the spectrum, the palette employed by the Impressionists and the Fauves. Yet there is another aspect of color, the deeper hues, seldom discussed, running from deep blues and greens to dark, rich blacks, often employed by the Symbolists in the 1890s and early 1900s to convey personal and deeply felt moods, and often nocturnal in spirit, evoking the dark side of the psyche. These colors were banished by the Impressionists, but a subsequent generation, including the young Picasso during his Blue Period, sought the lingering emotional effect rather than the Impressionist moment and often explored the dramatic effects offered by the full range of dark hues. By 1916 modernists such as Matisse and Mondrian had fully embraced black and white, which came to be considered primary colors, equal to the traditional primaries of red, yellow, and blue.

PLATE 41

A Symbolist mood of mystery lurking in a nighttime setting is dramatically evident in Frederic Remington's _Moonlight, Wolf_ of 1909, a remarkably modern picture for its sense of the contingency of existence. Its image of a single, lone creature, isolated before the forces and the vastness of the cosmos, echoes the modern condition; its simple yet inspiring depiction of the universe, the dots of distant yellow stars reflected in the water, connecting the earth and heavens, suggests a western rendition of the motif in van Gogh's famous _Starry Night_.

Later Americans, although more abstractionist in their approach, continued to explore the heightened expressive possibilities of nocturnal scenes and their dark palettes. One example is Georgia O'Keeffe's _Wave, Night_ of 1928, a beautiful, serene paint-

Vincent van Gogh
The Starry Night, 1889
Oil on canvas, 29 x 36 ¼ inches
The Museum of Modern Art;
acquired through the Lillie P. Bliss
Bequest. (472.1941)
Digital image © The Museum of
Modern Art/Licensed by SCALA/
Art Resource, NY

Frederic Remington *Moonlight, Wolf,* ca. 1909

PLATE 42

Georgia O'Keeffe *Wave, Night*, 1928

PLATE 43

Oscar Bluemner *Radiant Night*, 1932–33

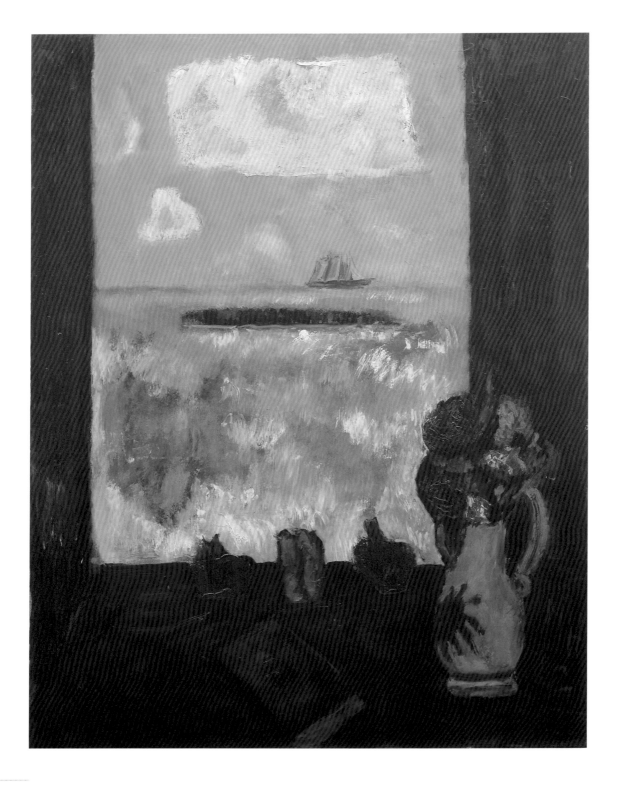

PLATE 44

Marsden Hartley *Summer, Sea, Window, Red Curtain*, 1942

ing, set on the Maine coast, which offers a depiction of the sea that is very different from Winslow Homer's, its calm recalling the work of Fitz H. Lane in the mid-nineteenth century. Simultaneously evoking a sense of ease in the world, as well as one filled with foreboding, O'Keeffe's view of the vast and mysterious sea gives way to the cosmos itself, anchored by the barely visible circle of the lighthouse, almost like the moon, at the very top. The painting connects man, earth, sea, and sky, elements with biblical implications. The gentle gradation of darker hues that marks the subtle, masterful passages of painting takes us through a voyage of time and space as our eyes move over the surface.

Connections to the cosmos abound in American landscapes and are often created by strong color: Lane's golden sun and sea, as in *Fishing Boats at Low Tide*, painted about 1850–59; Homer's views of man and ocean; the literal fusion of house, sea, and sky in Marsden Hartley's 1942 scene of the Maine coast, *Summer, Sea, Window, Red Curtain*; the brilliant sun blazing in the center of Dove's 1935 painting *Autumn*, which animates the surrounding landscape; and even Avery's apparently ordinary seaside view in *Sea Gulls—Gaspé*. All can be seen as depicting the beginnings of creation itself, emerging from a primeval element, a theme that would be developed by Rothko and Gottlieb.

PLATE 9

PLATE 44

A far more overtly menacing nocturnal scene is Oscar Bluemner's *Radiant Night* of 1932–33, a painting filled with restless movement that provides a contrast to the stillness of O'Keeffe's nighttime view. One of this country's most accomplished painters and colorists, Bluemner is only now receiving his just recognition. The character of the radiance in the painting's title can be read at several levels. Bluemner invests the scene with tantalizing anthropomorphic and animal references—the house with the black eyes, the red hand rising at the right, the looming figure of the tree at left, the cat's claws at the upper left.[7] The intense movement makes the painting appear to teeter and vibrate, perhaps a statement referring to the economic collapse of the United States during the Depression. Like Rothko after him, Bluemner called the images in his paintings "my actors," and here they play on the spectator's soul.[8] Surely no American artist made such powerful use of black and white until Franz Kline in his abstractions after 1950. We then might look ahead, to the downbeat mood of the gritty Lower East Side captured by the young Frank Stella in his pivotal *East Broadway* of 1958, an early work by the artist that forecast his soon-to-follow "Black Paintings" of 1959, which are pervaded by mystery and ambiguity.

PLATE 43

7 See Jeffrey R. Hayes, entry for Oscar Bluemner, in Faxon, Berman, and Reynolds, *Addison Gallery of American Art*, pp. 332–33.

8 Quoted in ibid., p. 333.

In a far more optimistic vein, however, we must consider the wide emotive range that the close-valued darker hues of modern works can induce. Black dominates Stuart Davis's *Red Cart* of 1932, making it almost appear as if it were a nocturnal scene. Black is also a major element in the pure abstraction *Bent Black (A)*, painted in 1940 by Josef Albers, a key artist in America and in the development of color construction. When

PLATE 34

PLATE 47

PLATE 45

Franz Kline *Abstract*, 1948

Frank Stella *East Broadway*, 1958

PLATE 47

Josef Albers *Bent Black (A),* 1940

Albers arrived in the United States in 1933 from the Bauhaus in Germany, he brought with him an unsurpassed depth of color knowledge and practice that instilled countless artists and students at Black Mountain College and later at Yale with a new and far greater awareness of color than anything previously known in this country. His importance was later veiled in the wave of Abstract Expressionism that occurred in the 1950s; but with the reintroduction of abstract geometric formats in the 1960s, we have come to understand once more his significant role in the development of color and abstract art internationally in the twentieth century. An early high point of Albers's work, *Bent Black (A)* uses color in an abstract mode, reminding us that during the 1930s modernist art continued and developed at the same time as the more familiar Social Realist and Regionalist modes commonly associated with the Depression era.

It has been harder in this country to establish a broad understanding of the language of geometric abstraction, for we are too quick to assume that geometric art is cold and impersonal. It is intense and emotively powerful, brought alive by the power and richness of color. Albers insisted on set formats based on order, clarity, precision, and careful disposition and weighing of color. Geometry is far from static, however, for all these qualities together create a discrepancy between apparently simple physical facts of the painting and the resulting ambiguities of psychic effect. Thus the abstract shapes that seem so simple and clear are in fact filled with pictorial illusionism and with ever-changing perspectives and perceptual facts that confront and challenge us anew each time we experience the painting. These works tell us—indeed, demand of us—that we look closely at the world around us.

The forms and colors in *Bent Black (A)* are coeval, anticipating the later abstraction of Reinhardt and Stella, among many others, and make clear that any discussion of color must include its weight, density, transparency, and scale, as well as the sheer amount of pigment. We may be surprised to learn that each of the black, gray, and white hues occupies an area of equal size, balanced by the tension between the confines of the painting and what appear to be sharp planes cutting into the viewer's space. Indeed these planes help explain why Albers, like Bluemner, could refer to the "face" of his colors and why he could observe that "art is not to be looked at, art is looking at us."[9] All elements are held in harmony, a metaphor for a higher order, a world harmony, bespeaking Albers's search for a spiritual level to his art, as had so many abstract artists before and after him.

For many American artists in the modern period, the two giants of color usage were Cézanne and Matisse, both of whom established principles of color construction that are still being defined today. The continuing legacy of Cézanne, often as seen through the eyes of Matisse, is a recurring theme in American work. Maurice Prend-

9 Josef Albers, *Homage to the Square* (New York: The Museum of Modern Art, 1964); reprinted in Rose, *Readings in American Art since 1900*, pp. 173–74.

PLATE 48

Man Ray *Ridgefield,* 1913

PLATE 49

Morton Schamberg *Landscape in Green*, ca. 1911–12

PLATE 50

Patrick Henry Bruce *Peinture/Nature morte*, ca. 1924

ergast, who may seem to belong more to the nineteenth than the twentieth century, is this country's first true modernist, the first American artist to fully absorb the color-construction lessons of Cézanne and transform them into a personal, independent art. Prendergast's figures leisurely posed in a park in *The Swans* recall Cézanne's late series of grand compositions of bathers, which inspired any number of modern artists. The touches of paint, feathery yet binding the surface like a mosaic, echo Cézanne's system of parallel areas of pigment, embodying the French painter's dictum that when color was at its richest, form was at its fullest. This method of parallel stroking is made literal in a painting by another American modernist, Man Ray, whose landscape *Ridgefield*, of 1913, sparkles with high-keyed reds and yellows that illuminate a vista recalling that of Cézanne's seminal Mont Sainte-Victoire series.

PLATE 48

The equation of color with form, central to Cézanne's approach, is also evident in works such as Morton Schamberg's *Landscape in Green* of about 1911–12. Here color flows easily and openly, virtually an independent force, tracing an organic pattern over much of the surface and making the painting far more abstract than it first appears. It is the color itself that becomes the subject and dictates the structure of the painting. In this organic flow we follow the hand of the artist, which recalls the brilliant hues and biomorphic shaping in Dove's *Autumn* and, later, the allover pictorial tracing of the surface made famous by Jackson Pollock after 1945.

PLATE 49

By far the fullest exposition of color and its principles in the Addison's collection is found in Patrick Henry Bruce's brilliant *Peinture/Nature morte* of about 1924. The painting demonstrates how traditions are extended by the creative artist into new pos-

PLATE 50

Henri Matisse
The Red Studio, Issy-les-Moulineaux, 1911
Oil on canvas, 71¼ x 72¼ inches
The Museum of Modern Art; Mrs. Simon Guggenheim Fund (8.1949)
© 2005 Succession H. Matisse, Paris/Artists Rights Society (ARS), New York
Digital image © The Museum of Modern Art/Licensed by SCALA/Art Resource, NY

sibilities. The format itself is a modern updating of the radically tilting tables and collapsing beams found in Cézanne's monumental late still lifes, still another of the French artist's genres that held out continuing challenges for the twentieth-century artist. At the same time its precision of rendering and of the placement of objects in a pictorial architecture situates Bruce's painting in the American still-life tradition of the exacting depictions of common objects.

Bruce spent his adult life in Paris, where he studied with Matisse, who taught him to look carefully at Cézanne. From Cézanne, Matisse, Seurat, and the Orphists Robert and Sonia Delaunay, Bruce absorbed a history of color and color painting, its methods and its underlying principles. Too often, we think of color theory as dry and mechanical, but as Bruce, and later Albers, demonstrates, it is only an initial guide to help launch the individual sensibility and intuition of the artist. Through these principles, Bruce turned the domestic still life—composed of shapes of daily living such as glasses, fruit, a round of cheese, and pieces of wood taken from the antique furniture he collected—into a vibrant symphony of color orchestration. He

employed well-established color principles—simultaneous contrast, the harmony of contrast, gradation of close-valued hues, and use of varied color chords—to create a pulsating ensemble that dazzles the eye and confounds the mind through its tension between the surface flatness and the illusionistic depiction of shapes. This type of abstract illusionism anticipates Albers and later, in the 1960s, such artists as Frank Stella.

Peinture/Nature morte, like the paintings of Avery, Hassam, and Twachtman, is a meditation on the color blue, used in myriad combinations and gradations. Its all-over color construction looks ahead to the exactitude of color and large-scale chromatic surfaces found later, although in more condensed formats, in the work of Ad Reinhardt and John McLaughlin. Bruce's painting also shows how the varying weights and densities of color affect the work and its impact on the viewer, a principle taken to an extreme in the relief-like surfaces of Pollock, which strike us as forming nothing less than a wall of color, a physical object in its own right. Color as weight and density and variation of touch and stroke are immediately apparent in Marsden Hartley's epic painting *Summer, Sea, Window, Red Curtain*, which conveys through its brushwork alone a powerful expression, as well as in John Marin's intense *Movement: Seas after Hurricane Red, Green, and White, Figure in Blue* of 1947, totally self-contained within the handcrafted frame made by the artist. This heightened expressionism coincides and merges with the new expressionism of a younger generation, which includes Pollock, whose work of the early 1940s signaled the emergence of a new pictorial intensity that marked the full coming of age of modern art in America.

PLATE 1

A far different effect derives from the radiant spread and opening into space of the glorious and brilliant color in *Exaltment* of 1947, by Hans Hofmann, who with Albers, his fellow immigrant from Germany, was, from 1932 on, one of this country's most influential teachers of color and abstraction. (By that same year, this painting was in the collection of Patrick and Maude Morgan, the legendary teachers and artists at Phillips Academy, where it was seen by the young Frank Stella, and served as a model for the powerful line of his early work, as well as the gestural configurations of his post-1975 art.) *Exaltment* reminds us why the critic Clement Greenberg could say that with Hofmann "one could learn more about Matisse than one could from Matisse himself."[10] One need only see and feel the very different effects of four types of yellow in the painting, ranging from sweet and full to acid, to understand the kinds of emotional and physical response that Hofmann could wring from a single hue. The notion of complexity within a single hue, but in a very different mood, occurs in Pollock's *Phosphorescence*. Here, the field of gray, a rich and powerful color in itself, is set off by and contrasted with a series of multiple, spotted areas of high-keyed reds and yellows.

PLATE 51

10 Clement Greenberg, "The Late Thirties in New York" (1957 and 1960), reprinted in *Art and Culture, Selected Essays* (Boston: Beacon Press, 1961), p. 232.

PLATE 51

Hans Hofmann *Exaltment*, 1947

PLATE 52

Alfred H. Maurer *Still Life with Pears,* ca. 1930–31

CUBISM

Along with color, Cubism was the other structural system that decisively shaped the course of modern art in the twentieth century. The first wave of Cubism occurred prior to 1914, but during the 1920s and early 1930s, often thought of as a period when modernism was on the wane, a second Cubist wave took firm hold in American art. The purest example of a strict Cubist vocabulary may be _Still Life with Pears_, of about 1930–31, by Alfred H. Maurer, a pioneering figure in American modernism, although overlooked in late twentieth-century accounts of art history. Maurer contributed significantly to the international body of Cubist art and can be said to have created distinctive American variants of the style that went beyond French Cubism. Hans Hofmann had it right when he said in 1950 that Maurer was a forerunner of a "true and great American tradition" that was carried on after 1945.[11]

PLATE 52

Still Life with Pears is a modest still life consisting of a bowl and fruit set on a table, an unremarkable subject typical of Cubist art; it is radical not for the subject but for its painterly methods, reminding us once again that the modernity of a painting does not always derive from its subject. The still life is set on a drastically tilted table, virtually flattened and all but eliminating pictorial depth and space, and structured by means of a grid of broad planes spread across the surface. The grid allows us to see several views of an object simultaneously as, for example, the bowl and the glass, in which we peer straight down into the top and center while we also view the sides. The center of the painting—the bowl, fruit, and table—is composed primarily of multiple overlapping layers of planes of varying hues and paint densities, allowing an almost seamless fusion of space and depth, of solid and void, of empty and full, front and back. The overlapping of planes was a standard Cubist device, but Maurer takes this idea to another level by using a literal, physical overlapping of planes achieved through his sublime use of glazing one layer of paint over another, one surface fusing with the others. This enables us to see multiple aspects of the subject simultaneously, thus blending time and space, a metaphor for the modern condition and experience, as if the artist were painting with an X-ray machine, a technology that we now know did influence modern painting.[12] The sensation is heightened by the use of the quasi-illusionist geometric shape at right, and the clearly drawn pears, which enables the viewer to measure and to contrast the differences of the painterly means and the ways we experience them within the work.

Thus in Maurer's work we move—in time, but a compressed time—from older pictorial means to the new modernist vocabulary of Cubism, indicating the passage of historical and present time, a variant of the influential concept of _durée_, developed by the French philosopher Henri Bergson and widely apparent in modernist art and thought in the early years of the twentieth century.[13] All this is achieved through a sequence of

11 Hans Hofmann, "Hartley—Maurer: Contemporaneous Paintings" (New York: Bertha Schaefer Gallery, 1950), n.p.

12 For this and other ways science has impacted modern art, see Linda Dalrymple Henderson, "Duchamp in Context: Science and Technology," in _"The Large Glass" and Related Works_ (Princeton, NJ: Princeton University Press, 1998).

13 For a fuller discussion of Bergson (1859–1941) and his impact on the art of the generation of 1914, see William C. Agee, "Le Cheval Majeur (The Large Horse)," in George Heard Hamilton and William C. Agee, _Raymond Duchamp-Villon_, (New York: Walker and Co. with M. Knoedler & Co., Inc., 1967), pp. 87–103.

dazzlingly virtuoso pure painting, as well as a sequence of planes of color in varying degrees of transparency, both characteristics that mark Maurer's Cubist paintings of this period as a high point in American art. Sadly, it was not to last, for Maurer died a suicide in 1932, unable to withstand the lack of understanding of his art by his father, another all-too-familiar and tragic story in American modernism.

By the mid-1920s, Cubist practice had expanded and evolved so that it could be used as the basis for any number of pictorial formats, some more and some less pure in their reliance on the first principles of the style. This has sometimes been interpreted in American art as a misunderstanding of Cubism, through a kind of American naïveté, or even ignorance, of mainstream European practice. But it is no such thing; rather, it is an example of American pragmatism and ingenuity, the willingness to test and experiment, to work with materials and stylistic possibilities to find a personal and authentic art statement. Thus Cubism could be adopted as a means to convey color, so that the mixing of high color with a grid that had seemed separate and apart in much European art became a common practice for American artists. Through this process, one generation built on another, extending the language of modern art and leading to American art's coming of age.

Chief among those who fused color and Cubism was the expatriate American Patrick Henry Bruce, who lived his entire adult life in Paris and, like Maurer, died a suicide. His "Compositions" of 1916 were Cubist-based abstractions that interpreted the light, color, and movement found at the fashionable Parisian dance hall the Bal Bullier. These paintings are key monuments in the history of modern color expression and were the basis for the artist's abstract still lifes of the 1920s, such as *Peinture/Nature morte*. The still lifes clearly show the purist distillation of Cubism that marked much of the art of the 1920s, a drive brought on by the worldwide movement to a more careful, clearly constructed type of art derived from a Cubism now based on solid, stable foundations, in the wake of the chaos and destruction of World War I. They also recall the precision of drawing in still lifes of John F. Peto and William M. Harnett. Bruce's still life represents a more expansive type of Cubism, evident in the large planes that provide the structural supports for the table and still life, which carry the extensive, brilliant passages of color.

Patrick Henry Bruce
Composition II, ca. 1916
Oil on canvas, 38³/₈ x 51¹/₄ inches
Yale University Art Gallery; Gift of Société Anonyme

Stuart Davis
Egg Beater No. 4, 1928
Oil on canvas, 27¹/₈ x 38¹/₄ inches
The Phillips Collection,
Washington D.C.; acquired in 1939

This broader, more open Cubism is also apparent in the structure of Stuart Davis's *Red Cart*, a painting that, like Bruce's, features sequences of brilliant and rich color. The work is a culmination of a series of Cubist paintings Davis began with his famous "Egg Beater" series in 1927–28, at the same time Maurer inaugurated his Cubist still lifes. These pivotal works were followed by a series of paintings, including views

Edward Hopper *Manhattan Bridge Loop*, 1928

Irene Rice Peirera *Light Is Gold*, 1951

of Paris, often thought to be a relaxation or retreat from the rigorous structure of the "Egg Beaters." On the contrary, they are nothing of the sort, but are rather a systematic exploration of the multiple formal and expressive possibilities of Cubism that Davis conducted until the end of his life.

Red Cart, painted in 1932, is based on the real, known topographic sights in the seaport of Gloucester, Massachusetts, a town where Davis had spent half of every year, beginning in 1915. He loved its atmosphere, particularly its architecture, not only that of the historic buildings but the architecture of the ships' masts, which provided a ready-made basis for his Cubist explorations. Davis was not the first to examine the geometries of ships' rigging; we need only compare *Red Cart* to the crisscrossing masts in a much earlier picture of another type altogether, *Fishing Boats at Low Tide* by Fitz H. Lane, another of the many artists drawn to the scenic port of Gloucester. But for all its basis in a known locale, Davis's work also reveals a pictorial humor. The dockside scene is presented as if painted on a stage flat, thus declaring that for all its topographic exactitude, the painting is finally a two-dimensional, fictive construction of three dimensions on a flat surface, a twist that is surely unique in the body of international Cubist art.

A taut pictorial architecture is also at the heart of Edward Hopper's *Manhattan Bridge Loop* of 1928. At first glance, Hopper might seem to be the last artist we would even remotely associate with Cubism, until we look closely and compare this painting with Bruce's *Peinture/Nature morte*, executed only some four years earlier. There are marked similarities in the structures of the two works: strong horizontal planes crossing the length of the Hopper emphasize the sense of lateral movement, anchoring and defining the structure, not unlike the broad diagonal planes that sweep across the Bruce. In turn, Hopper's painting is bisected by the forceful, sure verticals of the buildings, lamp, and gate, forming a kind of realist version of the Cubist grid. This framing accounts in great part for the solidity and tightly knit composition of Hopper's work, the elements that help to make the artist's paintings so compelling. It was this structure that Bartlett H. Hayes, Jr., then director of the Addison, examined in his aptly titled 1939 exhibition *The Architecture of a Painting*, which was based on the Hopper painting. The analogy is not so far-fetched when we consider that Bruce and Hopper had been friends and fellow students in New York in the early years of the twentieth century. Like Stuart Davis, they both studied with Robert Henri, among the most influential and important teachers in America and the equal of Albers and Hofmann in his impact on successive generations of young artists. Among Henri's lessons was the fundamental importance of a well-constructed painting. Contemporary accounts document the students' ongoing discussions of the formal and structural problems of painting, all of which evidenced an awareness of new modernist,

Charmion von Wiegand *Untitled (Geometric Abstraction)*, ca. 1945

PLATE 56

Burgoyne Diller *Wall Construction*, 1945–47

structural initiatives in picture making, including the rigors of Cubism.

The planar grid of intersecting horizontal and vertical elements, which formed the basis of Cubism, lasted well into the twentieth century and accounted for a broad range and depth of abstracting art. Just as Mondrian had worked from Cubism toward the purist abstraction of his later art, so too did numerous American artists develop a personal and idiosyncratic type of abstraction by using Mondrian as a departure point. Burgoyne Diller and Charmion von Wiegand were two of the most significant American painters who could trace their lineage to Mondrian and de Stijl, a movement born of the chaos of World War I and predicated on the premise that an abstract art based on clarity and order could realize a new world given to balance, serenity, and harmony. However, these artists were not lifeless imitators of Mondrian, as is so often thought, but rather were vital and original artists who chose to work within set formats of distilled Cubist grids. They demonstrate how far the lessons of Mondrian could be taken and extended them into new art forms. This is exemplified by Diller's *Wall Construction* of 1945–47, a unique rendition in three dimensions of the simplest arrangement of horizontal and vertical elements.

Von Wiegand, too, built on the work of her close friend Mondrian, particularly his late work executed in New York just prior to his death in early 1944. In those paintings Mondrian introduced a multiplicity of elements inspired by the pace of life in New York City. Von Wiegand took up the challenge and in her work *Untitled (Geometric Abstraction)* of about 1945 introduced an even greater variety of hues and shapes, demonstrating that there were no limitations to Mondrian but rather that his art could open onto infinite new possibilities. The Cubist grid also could provide the structural basis for an art as personal and whimsical as Joseph Cornell's 1949 *Cage*, or for the shifting and underlying patterning in Irene Rice Peirera's 1951 work *Light Is Gold*, a dramatic contrast to the otherwise soft, amorphous surface blendings of color. It is apparent even in *Movement: Seas After Hurricane Red, Green and White, Figure in Blue*, the 1947 painting by John Marin, who despite his painterly, expressionist approach, deeply respected the structure of Mondrian. Later, still more distilled forms of abstraction, such as appeared in the work of Josef Albers, as well as that of Ad Reinhardt and the California artist John McLaughlin, found their compositional source in early Cubism.

It has been widely held that Cubism had run its course by 1945, but in fact it continued to yield fresh art of high achievement well into the 1960s and contributed significantly to America's coming of age. Indeed, it can be said that, in its shift to Cubist structure, the art of Charles Sheeler underwent a dramatic transformation. Sheeler had experimented with Cubism early in his career

PLATE 56

PLATE 55

PLATE 57

PLATE 54

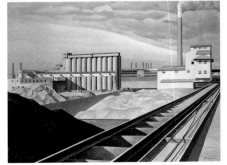

Charles Sheeler
Classic Landscape, 1931
Oil on canvas, 25 x 32¼ inches
National Gallery of Art, Washington;
Collection of Barney A. Ebsworth
Image © 2005 Board of Trustees,
National Gallery of Art, Washington

PLATE 57

Joseph Cornell *Cage*, 1949

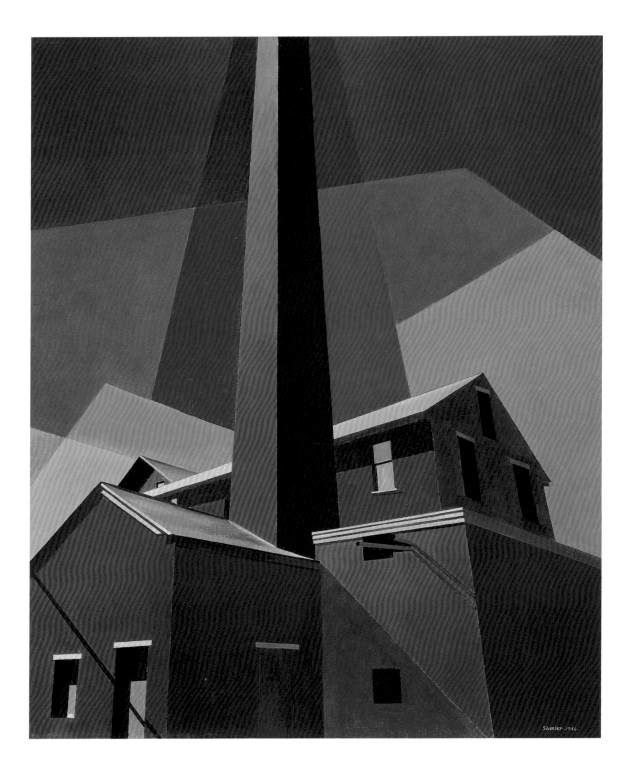

Charles Sheeler
Ballardvale Mill, 1946
Gelatin silver print, 10 x 8 inches
Addison Gallery of American
Art, Phillips Academy,
Andover, Massachusetts; gift of
Saundra B. Lane in honor
of Jock Reynolds (1998.168)
Copyright The Lane Collection

Charles Sheeler
Ballardvale Revisited, 1949
Tempera on paper, 3 7/8 x 3 1/2 inches
Addison Gallery of American
Art, Phillips Academy, Andover,
Massachusetts; museum purchase
(1995.45)

Charles Sheeler
New England Irrelevancies—
Study, 1953
Tempera on glass, 9 3/8 x 7 5/8 inches
Addison Gallery of American
Art, Phillips Academy, Andover,
Massachusetts; gift of Mr.
and Mrs. William H. Lane (1969.9)

but by the early 1920s had settled into a precisionist type of figuration in paintings such as *Classic Landscape*, icons of American art that portrayed American industry in all its glory, as the promise of the future. By 1945, however, the style had run dry, in part because it was too literal a translation of Sheeler's photography, a medium that the artist held dear. His art seemed at an impasse.

The solution, one that would result in some of the best art of Sheeler's career, came as a result of a six-week residency at Phillips Academy in Andover, conceived by Bartlett Hayes. Through the residency, Hayes hoped to spur the growth of the Addison's contemporary collection by acquiring a current work that had a direct connection to Andover. Sheeler came to Andover in the fall of 1946. Hayes did not ask him to teach or work, only to be a presence, listening and looking. Sheeler explored the

campus and its environs, as was his habit in getting to know a new place, and took photographs that served as shorthand notes. The new and invigorating atmosphere seems to have cleared his eye and his mind, opening the way for new solutions and vital new directions in his art. In the course of his explorations, he discovered the old and abandoned mill buildings, already in decline, in the section near Andover known as Ballardvale, just south of the campus. The stark, aging beauty of the mills captured his imagination, appearing like newly discovered remnants of long-lost ancient monuments. They offered a striking contrast to what Sheeler had seen of American industry fifteen years earlier, as embodied in the sleek, futuristic beauty of Henry Ford's mammoth empire at River Rouge, which the artist had carefully recorded. The mills seemed to represent an older and passing America, heroic reminders of a bygone era. Perhaps the artist saw something of himself and his career in these old buildings, forgotten by history but surely worthy of resurrecting.

Sheeler captured the monumental beauty of these buildings through a brilliant and innovative synthesis of painting and photography. Instead of using his earlier means of incorporating a detailed and exacting transcription of the photographs, he looked at the photographs with the eye of a painter. He extracted from them their broad structural forces, translating them on canvas into abstract compositions of flat, richly colored interlocking planes. Retrieving the Cubist vocabulary he had used early in his career, now, later in life and with increased experience, he imbued it with a new formal and emotive complexity and assurance. This he achieved by a process of arranging and rearranging, possibly of views from more than one photographic image, of balancing and shifting to find the desired effects

PLATE 58

and harmonies. The painting that is simply titled *Ballardvale*, executed in 1946, simultaneously incorporates multiple views and shifting perspectives, with each architectural section seeming to be seen from a different angle. All are anchored and centered by the soaring chimney that reaches to the sky, to the limits of the painting and beyond. The smokestack of industry has replaced the church steeple as the symbol of America, as the point of American imagination and aspiration, and it is viewed with the same reverence that Sheeler brought to his depictions of the architecture of Chartres Cathedral some years earlier.

Ballardvale launched a subsequent series of paintings, which Sheeler pursued for seven years, based on the same industrial theme and extending the use of his photography to include the superimposition of multiple prints and negatives as a way to combine images of different sites—a remarkable fusion of space, time, and place. In this sense, Sheeler, like other painters and photographers, from Alfred Stieglitz to Jackson Pollock, engaged in the essentially modernist practice of working directly with the materials and using them as a starting point to create new and distinctive works of art. It was a process that enabled Sheeler to give new life and vitality to his late work, using the supposedly outworn idiom of Cubist geometry, which in fact was undergoing a vital resurgence at the same time that the painterly art of Abstract Expressionism was apparently sweeping away all that had gone before it. In the vanguard of this resurgent Cubism, along with Sheeler, was Stuart Davis. These two artists, who were widely thought to belong to another era, were, in fact, on the verge of major new directions in their art. Burgoyne Diller and Charmion von Wiegand also can be said to be part of the group and were joined in the mid-1950s by two giants of the time, Hans Hofmann and David Smith, in extracting from Cubism the means for achieving the very best art of their careers.

There is a new clarity in Sheeler's work beginning in 1946, with a new directness and immediacy to the painting. This drive toward clarity is an inherent part of the artistic process, an aspect that has recurred throughout the history of modern art, almost always at points of personal, artistic, or historical crisis. The bold initiatives that accompany it open up an array of new possibilities and future directions that often reshape the course of art. In a real sense, Sheeler paved the way for a third wave of Cubism, from 1946 to 1965, to produce art of a high and innovative order. This process of clarification can be said in modern times to have started with Caravaggio, whose introduction of a stark graphic realism and dynamic pictorial energy broke the impasse caused by the logjam of insipid late-Mannerist painting. Eakins can be said to have done the same thing, for his gritty, unflinching realism broke through the legions of academic Beaux-Arts painters who choked American art, preventing it from

PLATE 59

Jackson Pollock *Phosphorescence*, 1947

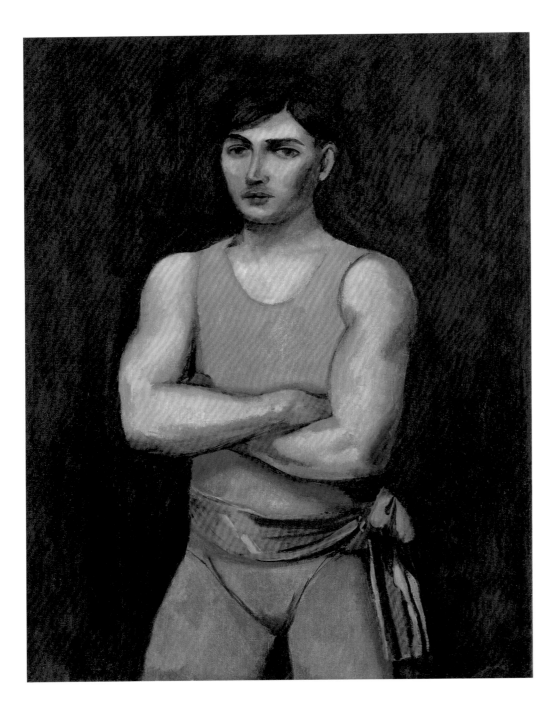

PLATE 60

Walt Kuhn *Acrobat in Green*, 1927

PLATE 61

John Graham *Mascara*, 1950

PLATE 62

David Smith *Structure of Arches*, 1939

capturing the essence of American experience.

Arthur Dove's lyric 1935 painting *Autumn* demonstrated how abstraction could capture the glory of a fall afternoon in the American landscape far more powerfully than the work of the countless uninspired Regionalists of the time. Dove teaches us that there is a subject matter to abstract art and that an abstract artist can be truly American. Pollock, in paintings such as *Phosphorescence*, moved to an allover type of abstraction that took on an unprecedented physicality, all the better to embody the feel of the landscape. The broad, sweeping gestures of Pollock and his fellow artists may in turn recall the sweeping stroke that literally forms the wind as a palpable presence in Winslow Homer's *The West Wind* or in the movement in Marin's 1947 seascape.

Within ten years, the painterly art of Abstract Expressionism and its followers began to look overly worked to a younger generation of artists, Frank Stella foremost among them. As in his *East Broadway*, Stella was prompted to move toward clarity, to eliminate the unnecessary, to open up the surface to a new, more simplified format of broadly spaced stripes within a single field, while retaining the power and directness of Pollock.

CLASSICISM

The drive to clarity in American modern painting—by which the artist, like the scientist, seeks the simplest, most economical and elegant solution—was often achieved by embracing means that can be considered classical in their source. Classicism here does not refer to a dry, academic traditionalism, but rather to work that takes inspiration from the best of classical art—whether that of ancient Greece and Rome or of the Renaissance—or that embodies the qualities of order, balance, harmony, and solidity that we consider at the core of the classical spirit. It can even derive from certain styles and practices that we associate with classical art, such as drawing. We often think of modern art solely as revolutionary, wishing only to break with the past, but this is not the case. Many artists, such as Cézanne, sought to make something solid and durable, to retain the best of the past while seeking a new and modern art. In this sense, painting is a conservative art, one that often strives to retain old values while extending them into newer forms.

Eakins foreshadowed this path in America at the end of the nineteenth century, updating a classical source in his figure of the boxer in *Salutat*, which presents the familiar nude in a new setting that grounds the painting in a known reality. The boxer is solid, like the ancient sculpture it recalls, permanent and immovable, a quality that characterizes the single figure in the 1927 painting *Acrobat in Green* by Walt Kuhn, a fine but undervalued painter who may well have had Eakins's as well as Cézanne's figures

PLATE 60

PLATE 63

Paul Manship *Flight of Night*, 1916

Alexander Archipenko *Torso in Space*, 1935, cast 1946

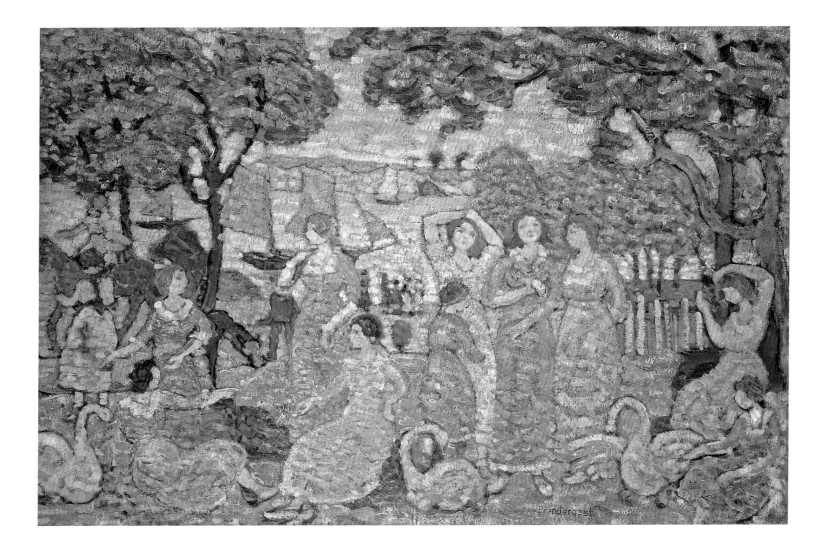

PLATE 65

Maurice Prendergast *The Swans*, 1914–15

in mind. Kuhn's work is representative of the 1920s, a period that, following the vast destruction of World War I, was marked by a desire to produce an art of classical solidity and sureness, built on a well-constructed foundation, the better to rebuild the world with values of permanence and endurance.

Other twentieth-century American artists also looked to a vision of the classical past as the means to convey a modernist pictorial language. In *The Swans*, Maurice Prendergast employed an idyllic, modern setting for his elegant women, depicted in contemporary dress, taking their ease, a setting and mood that recall a golden age, a lost Arcadian past from a distant classical time and place. The quiet pastoral mood of the painting is much different from the frenetic activity of Prendergast's earlier park scenes painted prior to the war. This change in outlook already reflects the call for an art that would reestablish a classical order and calm in the face of the war's destruction, a call that had begun by 1916, while the war still raged. This embrace of the classical as a continuing theme in the modern age is also apparent in two examples that use the medium of sculpture. While it is tempting to dismiss the 1916 sculpture *Flight of Night*, by

PLATE 63

Paul Manship, as old-fashioned, Manship, in fact, is emblematic of a deep-seated and continuing need for art to speak to and continue to redefine modern art's sources in the classical past, demonstrating a tradition that has far deeper roots than perhaps has been understood. It is the same sort of drive that defined Alexander Archipenko's sleek

Paul Manship
Venus Anadyomene, 1927
Marble on marble,
28⅝ x 22 inches
Addison Gallery of American
Art, Phillips Academy,
Andover, Massachusetts; gift
of anonymous donor
Photo copyright Richard Creek

and distilled version of a classical nude in his *Torso in Space* of 1935 and 1946.

PLATE 64

Classical overtones are also apparent in the work of Thomas Wilmer Dewing and John Graham.

We can also consider Patrick Bruce's *Peinture/Nature morte* in light of the quest for a new, more solidly constructed type of art. After 1918, Bruce's art had moved from the multiple overlapping shapes—rendered as if seen in simultaneous and intersecting movements—of his earlier abstractions to a format of carefully delineated and precisely constructed color planes built into an almost architectural mosaic. This shift to a more purist format has much in common with but is independent of the better-known "call to order" that followed directly after the end of the World War I. In fact, as early as his "Compositions" series of 1916, Bruce was moving from loose, painterly Futurist shapes to a more distilled, tightly constructed format, architectural in character, which formed the basis of his post-1918 still lifes, a move that demonstrates that American art was often at the cutting edge of modernist ideas. In their solidity Bruce sought to capture—in a more modern idiom—the classical spirit of balance, harmony, and order associated with old master painting, particularly the precise drawing of Andrea Mantegna and the monumentality of Cézanne's late still lifes. His intention was echoed in a letter to a friend in

Elie Nadelman *Seated Woman*, ca. 1919–25

PLATE 67

Gaston Lachaise *Seated Woman,* 1927, cast 1985

which Bruce stated, "You should be well prepared to appreciate my canvases after your trip to Greece."[14] Although American art of the 1920s is often described as a retreat, this was not really the case. Rather, many artists, like Bruce, sought to recast their modernist principles in light of what they saw as a necessity for a new order in the world. It can be said that during the 1920s modernism moved ahead but without the unbounded optimism of the prewar years.

Bruce's still life displays a constant tension between movement and stasis, order and ambivalence, harmony and conflict, a state of being that reflected his view of the world at the time. Whereas the artist had earlier sought to recall a classical world—first suggested to him by the ideals of Thomas Jefferson, which he had deeply admired as a youth—in the wake of international war, he saw those values profoundly altered. In his painting, their absolute clarity is undermined by the uncertainty and contradiction of the precipitous perspectives, which embodied the very essence of the modern condition. After his death, Bruce was virtually forgotten until the 1960s, when he was rediscovered by young artists such as Frank Stella, Ron Davis, and Al Held, whose move into abstract illusionism strongly recalls that of Bruce some forty years earlier.

Morton Schamberg
Painting (formerly Machine), 1916
Oil on canvas, 30 1/8 x 22 3/4 inches
Yale University Art Gallery;
Gift of Collection Société Anonyme

The work of Charles Sheeler was inspired by the precise qualities of drawing found in early Renaissance art. As a young student in 1908, he traveled to Europe with his close friend and fellow student Morton Schamberg. The two availed themselves of opportunities to look at recent modern art, but they paid equal attention to old master painting, especially the "primitives" of the fourteenth century, when they traveled through Italy. Both young men marveled at these artists' assurance of line, and both vowed to make it the basis of their own modernizing art, as evidenced by Schamberg's machine paintings of 1916, as well as Sheeler's post-1916 work. Indeed, their remarkable abilities as draftsmen should be seen as a modern extension of the old Florentine concept of *disegno*, firm and sure drawing that gave a painting a special gravity. For these two artists, the pure quality of Renaissance drawing became the standard by which they would measure their own art for the rest of their lives. Sheeler especially had also been stirred to explore line by his close study of Henri Matisse's *The Red Studio* when it was exhibited in 1913 at the Armory Show in New York. While Matisse's painting is usually considered noteworthy for its radical use of color, Sheeler was taken by its power and expressiveness of line and its "arbitrary design."[15] Matisse himself had gone to Italy to study the work of Giotto and Piero della Francesca in the summer of 1907 in order to introduce a classical solidity and weight to his art, which he feared had become too loose and impressionistic. The large-scale paintings he created immediately upon his return show a new direction

14 For this and other relevant quotations and a full discussion of Bruce's classical orientation, see William C. Agee and Barbara Rose, *Patrick Henry Bruce American Modernist* (Houston and New York: The Museum of Fine Arts, Houston, and The Museum of Modern Art, 1979), pp. 25–40.

15 Charles Sheeler, Unpublished Autobiography, Archives of American Art, Smithsonian Institution, reel NSHI, frame 74. For Sheeler and Schamberg in Italy and the effect of this period on their art, see William C. Agee, *Morton Livingston Schamberg* (New York: Salander-O'Reilly Galleries, 1982), pp. 4–6.

PLATE 68

Alexander Calder *Horizontal Spines,* 1942

toward bulk and density in his figuration.

Charmion von Wiegand and Burgoyne Diller were both influenced by the de Stijl movement, which belonged to the worldwide artistic drive toward a harmony and balance that would literally re-create post–World War I society, both physically and psychologically. Their art was new and personal, yet it was predicated on the basis of intersecting horizontals and verticals, initially developed by Mondrian and intended to embody the serenity and unity that we associate with classical art. In the same vein, the symmetry and balance of flat, colored planes in John McLaughlin's *Y-1958* is a modern embodiment of the classical values of order and harmony. McLaughlin's work, in fact, was included in the landmark exhibition *Four Abstract Classicists*, held in 1959 at the Los Angeles County Museum.

PLATE 69

NEW MATERIALS, NEW TECHNIQUES

America's coming of age was dramatically furthered by a willingness to explore and develop new materials and techniques. Sculpture in America in the first few decades of the twentieth century was more narrow in its reach than painting. The classicizing work of artists such as Paul Manship, Elie Nadelman, and Alexander Archipenko, while expressively rewarding, cannot be said to have conveyed the new formal and emotive directions of modern art. The exception, until his early death in 1935, was Gaston Lachaise, an artist whose work embodied a deep expressionist power rare in world sculpture at the time, as found in *Seated Woman*. The figure in this 1927 bronze seems to be at ease, but in fact contains a coiled energy, a succession of opposing material thrusts that speak of potential power and even deep and turbulent psychic drives, held in tension by the subject's apparent poise. Lachaise's early death was a serious loss for American art and left a large void in the realm of sculpture.

PLATE 67

A younger generation of sculptors born after 1900, however, was emerging. These artists, along with painters such as William Baziotes, Franz Kline, and Pollock, engaged more recent European modernism on new terms and would lead American art to a position of world prominence after 1940. Perhaps surprisingly, it was the sculptors, not the painters, who took an early and key role in absorbing new developments, signaling a far brighter future for American sculpture than anything it had known. Although this rise to world prominence is generally dated to the years after 1945, by 1940 the pioneering artists Alexander Calder and David Smith already had taken sculpture, and American art, to new levels of achievement that were reached in painting only in 1943–44. In large part, it was due to their willingness to extend an old American tradition of daring to experiment with new materials and techniques.

Calder was the first American artist born after 1900 to fully respond to the art

PLATE 69

John McLaughlin *Y-1958*, 1958

László Moholy-Nagy *Twisted Planes*, 1946

PLATE 71

Naum Gabo *Linear Construction No. 2 (Variation No. 1),* 1950

of Piet Mondrian, drawing from it ideas and possibilities that he then transformed into new and original art. Prior to 1930, Calder had been working in Paris with wire figures, using them to create a full miniature Circus, a motif long favored by French artists and earlier developed by George Bellows in America in *The Circus*. Acting as the ringmaster, Calder put on full performances of these witty and charming circus figures for artists and their friends, and he attained a certain renown in Paris. Yet he understood that while the figures were playful and popular, they were without potential for developing truly serious and ambitious art that could stand with the best of the time. Calder visited Mondrian, who had long lived in Paris, and was impressed by the large rectangles of color that the older artist had affixed to the walls of his studio. Inspired by Mondrian's pure abstraction, Calder proceeded to translate it into open and lightweight sculpture, as in *Horizontal Spines* of 1942, consisting of organic forms that derived from the biomor-

PLATE 68

phic shapes of Miró, whose influence was at its peak in 1930. Organic shapes could also be found in Dove's *Autumn* of 1935 and later in the work of the American Abstract Expressionists. Calder's work was a new kind of sculpture, freed from the pedestal, as well as from the weight and density of older sculpture, now with fluidly moving independent parts suggested by his own wire figures and the open constructions recently explored by Picasso and Juan González. It was another example of a brilliant American synthesis, a fusion of painting and sculpture that enabled three-dimensional art to become as free and inventive as modern painting.

Working in New York, David Smith took a similar path at almost the same time. Smith had begun as a painter but, seeking an art of greater material presence, had moved into collage and then three dimensions by 1932. Like Calder, he adopted new industrial techniques such as welding and industrial, non-art materials such as lightweight, flexible sheet metals in order to transform the advances of abstract painting into the medium of an open kind of sculpture. American artists were quick to employ the methods and materials of the machine shop, which opened up a whole range of expressive possibilities for sculpture. Among the first to pioneer the use of nontraditional twentieth-century materials were the Constructivists Naum Gabo and László Moholy-Nagy, European émigrés who also experimented with open structures in a purist vein.

The expressive range that Smith demonstrated by 1939, the year he made

PLATE 62

Structure of Arches, as well as the sheer power and intensity of his work, was one of America's great artistic achievements and was well in place before World War II. Here Smith used steel, which is closely associated with the twentieth century and the machine, to interpret what appears to be a reclining nude, perhaps inspired by Picasso's demonic nudes of the 1930s. The figure seems to arch back, at once supine but also

hostile and threatening, like some surrealist creature, half-human, half-animal. It is an imposing image, telling us of the heights that American modernism could reach in the 1930s and indicating that modernism was alive and well through the decade. Not only does it point the way for the new levels of accomplishment that American art would attain after 1945, but, like Calder's sculpture, it is a major statement in its own right. As such, the work can be seen as a symbol of the transfer of leadership in the art world to America, at a date earlier than 1945. Indeed, that this actually happened prior to 1945 is only one of the many lessons that an exploration of the Addison's collection has yielded and will continue to yield for years to come. It was the culmination of years of assimilation and growth, testing and experimentation, of themes, continuities, and traditions that became essential parts of American art. Those themes are only one part of this; Surrealism and its language of organic, biomorphic abstraction, pioneered by Arthur Dove in *Autumn*, for example, is but one of other important aspects. But they are a vital part, for in turn they helped propel America to the forefront of world art well into the 1960s and beyond, part of a coming of age, a vision of the new and possible, that is still being defined today.

Checklist of the Exhibition

Josef Albers
Bent Black (A), 1940
Oil on Masonite, 37½ x 27¾ in.
Addison Gallery of American Art, Phillips Academy,
Andover, Massachusetts; gift of Mrs. Frederick E.
Donaldson (1944.11)
PLATE 47

Alexander Archipenko
Torso in Space, 1935, cast 1946
Chrome-plated bronze
7 x 22¼ x 4½ in.
Addison Gallery of American Art, Phillips Academy,
Andover, Massachusetts; museum purchase (1946.5)
PLATE 64

Milton Avery
Sea Gulls—Gaspé, 1938
Oil on canvas, 30 x 40 in.
Addison Gallery of American Art, Phillips Academy,
Andover, Massachusetts; museum purchase (1944.82)
PLATE 40

William Baziotes
Three Forms, 1946
Oil on canvas, 28¼ x 36⅛ in.
Addison Gallery of American Art, Phillips Academy,
Andover, Massachusetts; bequest of Edward Wales Root
(1957.32)
PLATE 37

George Bellows
The Circus, 1912
Oil on canvas, 33⅜ x 44 in.
Addison Gallery of American Art, Phillips Academy,
Andover, Massachusetts; gift of Elizabeth Paine Metcalf
(1947.8)
PLATE 33

Albert Bierstadt
The Coming Storm, 1869
Oil on board, 9 x 13 in.
Addison Gallery of American Art, Phillips Academy,
Andover, Massachusetts; gift of Mrs. Leon Bascom
(1943.114)
PLATE 11

Ralph Blakelock
After Sundown, ca. 1892
Oil on canvas, 27⅛ x 37¼ in.
Addison Gallery of American Art, Phillips Academy,
Andover, Massachusetts; gift of anonymous donor
(1928.41)
PLATE 4

Oscar Bluemner
Radiant Night, 1932–33
Oil on canvas , 33⅞ x 46⅞ in.
Addison Gallery of American Art, Phillips Academy,
Andover, Massachusetts; museum purchase (1957.48)
PLATE 43

Patrick Henry Bruce
Peinture/Nature morte, ca. 1924
Oil and graphite on canvas, 28¾ x 36¼ in.
Addison Gallery of American Art, Phillips Academy,
Andover, Massachusetts; gift of Mr. and Mrs. William H.
Lane (1958.38)
PLATE 50

George de Forest Brush
Mother and Child, 1892
Oil on canvas, 45⅛ x 32⅛ in.
Addison Gallery of American Art, Phillips Academy,
Andover, Massachusetts; gift of anonymous donor
(1930.377)
PLATE 24

Alexander Calder
Horizontal Spines, 1942
Steel, wire, and aluminum, 54¼ x 50 x 22½ in.
Addison Gallery of American Art, Phillips Academy,
Andover, Massachusetts; museum purchase (1943.121)
PLATE 68

William Merritt Chase
The Leader, ca. 1875
Oil on canvas, 26¼ x 15⅝ in.
Addison Gallery of American Art, Phillips Academy,
Andover, Massachusetts; gift of anonymous donor
(1931.1)
PLATE 14

Frederic E. Church
Mount Katahdin, ca. 1856
Oil on canvas, 8⅛ x 11¾ in.
Addison Gallery of American Art, Phillips Academy,
Andover, Massachusetts; gift of Winslow Ames (PA 1925)
in memory of Edward Winslow Ames (PA 1892) (1937.5)
PLATE 22

Joseph Cornell
Cage, 1949
Wood, paper, metal screening, and glass
17¾ x 16⁷⁄₁₆ x 4⁵⁄₁₆ in.
Addison Gallery of American Art, Phillips Academy,
Andover, Massachusetts; museum purchase (1960.3)
PLATE 57

Jasper F. Cropsey
Greenwood Lake, New Jersey, 1866
Oil on canvas, 12 x 20 in.
Addison Gallery of American Art, Phillips Academy,
Andover, Massachusetts; museum purchase (1940.16)
PLATE 10

Arthur B. Davies
Mountain Beloved of Spring, ca. 1906–07
Oil on canvas, 18 x 40⅛ in.
Addison Gallery of American Art, Phillips Academy,
Andover, Massachusetts; gift of Miss Lizzie P. Bliss
(1928.1)
PLATE 7

Stuart Davis
Red Cart, 1932
Oil on canvas, 32¼ x 50 in.
Addison Gallery of American Art, Phillips Academy,
Andover, Massachusetts; museum purchase (1946.15)
PLATE 34

Maria Oakey Dewing
A Bed of Poppies, 1909
Oil on canvas, 25⅛ x 30⅛ in.
Addison Gallery of American Art, Phillips Academy,
Andover, Massachusetts; gift of anonymous donor (1931.2)
FRONTISPIECE

Thomas Wilmer Dewing
Reverie, before 1928
Oil on wood panel, 24¹⁄₁₆ x 19¾ in.
Addison Gallery of American Art, Phillips Academy,
Andover, Massachusetts; gift of anonymous donor
(1928.17)
PLATE 26

Burgoyne Diller
Wall Construction, 1945–47
Oil on board, 46½ x 46½ x 2¾ in.
Addison Gallery of American Art, Phillips Academy,
Andover, Massachusetts; museum purchase (2003.24)
Art © Estate of Burgoyne Diller/Licensed by
VAGA, New York, NY/ Est. Represented by the Michael
Rosenfeld Gallery
PLATE 56

Arthur Dove
Autumn, 1935
Tempera on canvas, 14 x 23 in.
Addison Gallery of American Art, Phillips Academy,
Andover, Massachusetts; bequest of Edward Wales Root
(1957.29)
PLATE 36

Asher B. Durand
Study of a Wood Interior, ca. 1855
Oil on canvas, 16¾ x 24 in.
Addison Gallery of American Art, Phillips Academy,
Andover, Massachusetts; gift of Mrs. Frederic F. Durand
(1932.1)
PLATE 5

Thomas Eakins
Elizabeth at the Piano, 1875
Oil on canvas
72⅛ x 48³⁄₁₆ in.
Addison Gallery of American Art, Phillips Academy,
Andover, Massachusetts; gift of anonymous donor
(1928.20)
PLATE 19

Salutat, 1898
Oil on canvas, 50 x 40 in.
Addison Gallery of American Art, Phillips Academy,
Andover, Massachusetts; gift of anonymous donor
(1930.18)
PLATE 20

Naum Gabo
Linear Construction No. 2 (Variation No. 1), 1950
Perpex with nylon monofilament, 24 x 17½ x 16½ in.
Addison Gallery of American Art, Phillips Academy,
Andover, Massachusetts; museum purchase, by exchange
(1952.19)
PLATE 71

Adolph Gottlieb
Untitled, ca. 1953
Oil and enamel on composite board, 20⁹⁄₁₆ x 28¼ in.
Addison Gallery of American Art, Phillips Academy,
Andover, Massachusetts; gift of Frank Stella (PA 1954)
Addison Art Drive (1991.43)
Art © Adolph and Esther Gottlieb Foundation/Licensed
by VAGA, New York, NY
PLATE 38

John Graham
Mascara, 1950
Oil on canvas, 23⅞ x 19⅝ in.
Addison Gallery of American Art, Phillips Academy,
Andover, Massachusetts; promised gift of Ruth Cole
Kainen (PL96.1)
PLATE 61

William M. Harnett
Still Life with Letter to Mr. Clarke, 1879
Oil on canvas, 11⅛ x 15 in.
Addison Gallery of American Art, Phillips Academy,
Andover, Massachusetts; gift of Harold Clarke Durrell
(1941.71)
PLATE 15

Marsden Hartley
Summer, Sea, Window, Red Curtain, 1942
Oil on Masonite, 40⅛ x 30⁷⁄₁₆ in.
Addison Gallery of American Art, Phillips Academy,
Andover, Massachusetts; museum purchase (1944.81)
PLATE 44

Childe Hassam
Early Morning on the Avenue in May 1917, 1917
Oil on canvas, 30¹⁄₁₆ x 36¹⁄₁₆ in.
Addison Gallery of American Art, Phillips Academy,
Andover, Massachusetts; bequest of Candace C. Stimson
(1944.20)
PLATE 29

Martin Johnson Heade
Apple Blossoms and Hummingbird, 1871
Oil on board, 14 x 18¹⁄₁₆ in.
Addison Gallery of American Art, Phillips Academy,
Andover, Massachusetts; museum purchase (1945.4)
PLATE 6

Robert Henri
Mary, 1913
Oil on canvas, 24⅛ x 20 in.
Addison Gallery of American Art, Phillips Academy,
Andover, Massachusetts; museum purchase (1933.21)
PLATE 31

Hans Hofmann
Exaltment, 1947
Oil on canvas, 59¾ x 47¾ in.
Addison Gallery of American Art, Phillips Academy,
Andover, Massachusetts; museum purchase (1960.6)
PLATE 51

Winslow Homer
Eight Bells, 1886
Oil on canvas, 25³⁄₁₆ x 30³⁄₁₆ in.
Addison Gallery of American Art, Phillips Academy,
Andover, Massachusetts; gift of anonymous donor
(1930.379)
PLATE 17

The West Wind, 1891
Oil on canvas, 30 x 44 in.
Addison Gallery of American Art, Phillips Academy,
Andover, Massachusetts; gift of anonymous donor
(1928.24)
PLATE 18

Edward Hopper
Manhattan Bridge Loop, 1928
Oil on canvas, 35 x 60 in.
Addison Gallery of American Art, Phillips Academy,
Andover, Massachusetts; gift of Stephen C. Clark, Esq.
(1932.17)
PLATE 53

George Inness
The Coming Storm, ca. 1879
Oil on canvas, 27¼ x 41¾ in.
Addison Gallery of American Art, Phillips Academy,
Andover, Massachusetts; gift of anonymous donor
(1928.25)
PLATE 12

Eastman Johnson
The Conversation, 1879
Oil on paper board, 22½ x 26¼ in.
Addison Gallery of American Art, Phillips Academy,
Andover, Massachusetts; museum purchase (1942.42)
PLATE 8

Franz Kline
Abstract, 1948
Oil on canvas, 37¼ x 24 in.
Addison Gallery of American Art, Phillips Academy,
Andover, Massachusetts; gift of Mr. and Mrs. William H.
Lane (1969.10)
© 2006 The Franz Kline Estate / Artists Rights Society
(ARS), New York
PLATE 45

Walt Kuhn
Acrobat in Green, 1927
Oil on canvas, 40⁷⁄₁₆ x 30¼ in.
Addison Gallery of American Art, Phillips Academy,
Andover, Massachusetts; bequest of Miss Lizzie P. Bliss
(1931.88)
PLATE 60

Gaston Lachaise
Seated Woman, 1927, cast 1985
Bronze, 12⅝ x 9½ x 7¾ in.
Addison Gallery of American Art, Phillips Academy,
Andover, Massachusetts; gift of The Lachaise
Foundation, Boston, MA (1995.22)
PLATE 67

Fitz H. Lane
Fishing Boats at Low Tide, ca. 1850–59
Oil on canvas , 12 x 18 in.
Addison Gallery of American Art, Phillips Academy,
Andover, Massachusetts; museum purchase (1943.33)
PLATE 9

Jacob Lawrence
Kibitzers, 1948
Egg tempera on Masonite, 20 x 24 in.
Addison Gallery of American Art, Phillips Academy,
Andover, Massachusetts; gift from the Childe
Hassam Fund of the American Academy of Arts and
Letters (1951.3)
PLATE 3

Louis Lozowick
Painting Sketch No. 2—New York, 1922
Oil on canvas, 20⅝ x 15¾ in.
Addison Gallery of American Art, Phillips Academy,
Andover, Massachusetts; promised gift of Jacob and Ruth
Kainen (PL96.3)
PLATE 2

George Luks
The Little Madonna, ca. 1907
Oil on canvas, 27⅜ x 22¼ in.
Addison Gallery of American Art, Phillips Academy,
Andover, Massachusetts; gift of anonymous donor
(1930.4)
PLATE 32

Man Ray
Ridgefield, 1913
Oil on canvas, 25 x 30 in.
Addison Gallery of American Art, Phillips Academy,
Andover, Massachusetts; museum purchase (1947.20)
PLATE 48

Paul Manship
Flight of Night, 1916
Bronze, 17½ x 12½ x 5⅜ in.
Addison Gallery of American Art, Phillips Academy,
Andover, Massachusetts; gift of anonymous donor
(1928.28)
PLATE 63

John Marin
*Movement: Seas after Hurricane Red, Green and White,
Figure in Blue*, 1947
Oil on canvas, 26½ x 32¼ in.
Frame made by the artist
Addison Gallery of American Art, Phillips Academy,
Andover, Massachusetts; Promised gift of
Norma B. Marin (PL2005.2)
© 2006 Estate of John Marin / Artists Rights Society
(ARS), New York
PLATE 1

Alfred H. Maurer
Still Life with Pears, ca. 1930–31
Oil on board, 26 x 36 in.
Addison Gallery of American Art, Phillips Academy,
Andover, Massachusetts; museum purchase (1945.20)
PLATE 52

John McLaughlin
Y-1958, 1958
Oil on canvas, 32 x 48 in.
Addison Gallery of American Art, Phillips Academy,
Andover, Massachusetts; museum purchase (1995.69)
PLATE 69

László Moholy-Nagy
Twisted Planes, 1946
Acrylic and steel, 16 x 34⅜ x 20⅛ in.
Addison Gallery of American Art, Phillips Academy,
Andover, Massachusetts; museum purchase (1949.12)
© 2006 Artists Rights Society (ARS), New York /
VG Bild-Kunst, Bonn
PLATE 70

Elie Nadelman
Seated Woman, ca. 1919–25
Cherry wood and iron, 31¾ x 12¾ x 18¾ in.
Addison Gallery of American Art, Phillips Academy,
Andover, Massachusetts; museum purchase (1955.8)
PLATE 66

Georgia O'Keeffe
Wave, Night, 1928
Oil on canvas, 30 x 36 in.
Addison Gallery of American Art, Phillips Academy,
Andover, Massachusetts; purchased as the gift of Charles
L. Stillman (PA 1922) (1947.33)
PLATE 42

Irene Rice Peirera
Light Is Gold, 1951
Glass, acrylic, lacquer, casein, and gold leaf,
30⅛ x 23¼ in.
Addison Gallery of American Art, Phillips Academy,
Andover, Massachusetts; museum purchase (1952.16)
PLATE 54

John F. Peto
Office Board for Smith Brothers Coal Company, 1879
Oil on canvas, 28¼ x 24 in.
Addison Gallery of American Art, Phillips Academy,
Andover, Massachusetts; museum purchase (1956.13)
PLATE 35

Jackson Pollock
Phosphorescence, 1947
Oil, enamel, and aluminum paint on canvas, 44 x 28 in.
Addison Gallery of American Art, Phillips Academy,
Andover, Massachusetts; gift of Mrs. Peggy Guggenheim
(1950.3)
PLATE 59

Maurice Prendergast
The Swans, ca. 1914–15
Oil on canvas, 30¼ x 43⅛ in.
Addison Gallery of American Art, Phillips Academy,
Andover, Massachusetts; bequest of Miss Lizzie P. Bliss
(1931.95)
PLATE 65

Ad Reinhardt
Abstract Painting, Red, 1952
Acrylic on canvas, 50 x 20 in.
Addison Gallery of American Art, Phillips Academy,
Andover, Massachusetts; gift of Frank Stella (PA 1954),
Addison Art Drive (1991.49)
© 2006 Estate of Ad Reinhardt / Artists Rights Society
(ARS), New York
PLATE 39

Frederic Remington
Moonlight, Wolf, ca. 1909
Oil on canvas. 20¹⁄₁₆ x 26 in.
Addison Gallery of American Art, Phillips Academy,
Andover, Massachusetts; gift of the members of the
Phillips Academy Board of Trustees on the occasion of
the 25th anniversary of the Addison Gallery (1956.2)
PLATE 41

Theodore Robinson
Valley of the Seine, 1892
Oil on canvas, 25¾ x 32⅜ in.
Addison Gallery of American Art, Phillips Academy,
Andover, Massachusetts; museum purchase (1934.3)
PLATE 28

Augustus Saint-Gaudens
The Puritan, after 1886, cast 1899
Bronze on Italian marble base
33 x 20⅜ x 12⅜ in.
Addison Gallery of American Art, Phillips Academy,
Andover, Massachusetts; museum purchase (1956.9)
PLATE 25

John Singer Sargent
Val d'Aosta: A Man Fishing, ca. 1906
Oil on canvas, 22¼ x 28¼ in.
Addison Gallery of American Art, Phillips Academy,
Andover, Massachusetts; gift of anonymous donor (1928.53)
PLATE 21

Morton Schamberg
Landscape in Green, ca. 1911–12
Oil on canvas, 10 x 13¾ in.
Addison Gallery of American Art, Phillips Academy,
Andover, Massachusetts; gift of Charles O. Wood III and
Miriam M. Wood (2002.21)
PLATE 49

Charles Sheeler
Ballardvale, 1946
Oil on canvas, 24 x 19 in.
Addison Gallery of American Art, Phillips Academy,
Andover, Massachusetts; museum purchase (1947.21)
PLATE 58

John Sloan
Sunday, Women Drying Their Hair, 1912
Oil on canvas, 26⅛ x 32⅛ in.
Addison Gallery of American Art, Phillips Academy,
Andover, Massachusetts; museum purchase (1938.67)
PLATE 30

David Smith
Structure of Arches, 1939
Steel with zinc and copper plating, 39⁵⁄₁₆ x 48 x 30¼ in.
Addison Gallery of American Art, Phillips Academy,
Andover, Massachusetts; purchased as the gift of Mr. and
Mrs. R. Crosby Kemper (PA 1945) (1982.162)
PLATE 62

Frank Stella
East Broadway, 1958
Oil on canvas, 85¼ x 81 in.
Addison Gallery of American Art, Phillips Academy,
Andover, Massachusetts; gift of the artist (PA 1954)
(1980.14)
© 2006 Frank Stella / Artists Rights Society (ARS),
New York
PLATE 46

John Twachtman
Hemlock Pool, ca. 1900
Oil on canvas, 29⅞ x 24⅞ in.
Addison Gallery of American Art, Phillips Academy,
Andover, Massachusetts; gift of anonymous donor
(1928.34)
PLATE 27

Charmion von Wiegand
Untitled (Geometric Abstraction), ca. 1945
Oil on canvas, 12 x 12 in.
Addison Gallery of American Art, Phillips Academy,
Andover, Massachusetts; museum purchase (2003.40)
Courtesy Michael Rosenfeld Gallery, LLC, New York, NY
PLATE 55

James McNeill Whistler
Brown and Silver: Old Battersea Bridge, 1859–63
Oil on canvas, 25⅛ x 29¹⁵⁄₁₆ in.
Addison Gallery of American Art, Phillips Academy,
Andover, Massachusetts; gift of Cornelius N. Bliss
(1928.55)
PLATE 23

Worthington Whittredge
Home by the Sea, 1872
Oil on canvas, 36⅛ x 54⅛ in.
Addison Gallery of American Art, Phillips Academy,
Andover, Massachusetts; museum purchase (1943.173)
PLATE 16

Alexander Wyant
Landscape, ca. 1880–89
Oil on canvas, 36¼ x 60 in.
Addison Gallery of American Art, Phillips Academy,
Andover, Massachusetts; gift of anonymous donor
(1928.38)
PLATE 13

Selected Bibliography

THIS BIBLIOGRAPHY CONSISTS OF VOLUMES AND
PUBLICATIONS THAT THE AUTHORS FOUND PARTICULARLY
USEFUL IN THE COMPOSITION OF THEIR ESSAYS.

Adams, Henry. *Eakins Revealed: The Secret Life of an American Artist*. New York: Oxford University Press, 2005.

Agee, William C. "Arthur Dove: A Place to Find Things." In *Modern Art and America: Alfred Stieglitz and His New York Galleries*, by Sarah Greenough et al. Washington, D.C.: National Gallery of Art, 2001.

——. "Le Cheval Majeur (The Large Horse)." In *Raymond Duchamp-Villon*, by George Heard Hamilton and William C. Agee. New York: Walker and Co. with M. Knoedler, & Co., Inc., 1967.

——. *Morton Livingston Schamberg*. New York: Salander-O'Reilly Galleries, 1982.

——. "Stuart Davis in the 1960s: 'The Amazing Continuity.'" In *Stuart Davis American Painter*, by Lowery S. Sims et al. New York: The Metropolitan Museum of Art, 1991.

Agee, William C., Peter Morrin, and Judith Zilczer. *The Advent of Modernism: Post–Impressionism and North American Painting, 1900–1918*. Atlanta: High Museum of Art, 1986.

Agee, William C., and Barbara Rose. *Patrick Henry Bruce American Modernist*. Houston and New York: The Museum of Fine Arts, Houston, and The Museum of Modern Art, 1979.

Albers, Josef. *Homage to the Square. American Artists on Art from 1940 to 1960*. New York: The Museum of Modern Art, 1964. Reprinted in *Readings in American Art since 1900*, edited by Barbara Rose. New York: Praeger, 1968.

Anfam, David. "Pollock Drawing: The Mind's Line." In *No Limits, Just Edges: Jackson Pollock Paintings on Paper*. Berlin and New York: Deutsche Bank and Solomon R. Guggenheim Foundation, 2005.

Apter, Eleanor S., Robert L. Herbert, and Elise K. Kenney. *The Société Anonyme and the Dreier Bequest at Yale University: A Catalogue Raisonné*. New Haven, CT: Yale University Press, 1984.

Baigell, Matthew. *A Concise History of American Painting and Sculpture*. New York: Harper and Row, 1984.

Batchelor, David. "Chromophobia, Ancient and Modern, and a Few Notable Exceptions." *Art and Design* (July/August 1997): 31–32.

Bell, Adrienne Baxter. *George Inness and the Visionary Landscape*. New York: National Academy of Design, 2003.

Bermingham, Peter. *American Art in the Barbizon Mood*. Washington, D.C.: National Collection of Fine Arts, 1975.

Bowditch, Nancy Douglas. *George de Forest Brush: Recollections of a Joyous Painter*. Peterborough, NH: Noone House, 1970.

Brettell, Richard R. *Modern Art, 1851–1929, Capitalism and Representation*. New York: Oxford University Press, 1999.

Brown, Joshua. *Beyond the Lines: Pictorial Reporting, Everyday Life, and the Crisis of Gilded Age America*. Berkeley: University of California Press, 2002.

Brown, Milton Wolf. *American Paintings from the Armory Show to the Depression*. Princeton, NJ: Princeton University Press, 1955.

Brownell, William C. "The Younger Painters of America: First Paper." *Scribner's Monthly* 20, no. 1 (May 1880): 1–15.

——. "The Younger Painters of America: Second Paper." *Scribner's Monthly* 20, no. 3 (July 1880): 321–35.

Burke, Doreen Bolger. "Painters and Sculptors in a Decorative Age." In *In Pursuit of Beauty: Americans and the Aesthetic Movement*. New York: The Metropolitan Museum of Art, 1986.

Burns, Sarah. *Inventing the Modern Artist: Art and Culture in Gilded Age America*. New Haven: Yale University Press, 1996.

Butterfield, L. H., Marc Friedlaender, and Mary-Jo Kline, eds. *The Book of Abigail and John: Selected Letters of the Adams Family, 1762–1784*. Cambridge, MA: Harvard University Press, 1975.

Cikovky, Nicolai, and Franklin Kelly. *Winslow Homer*. Washington, D.C.: National Gallery of Art, 1995.

Conrads, Margaret C. *Winslow Homer and the Critics: Forging a National Art in the 1870s*. Princeton, NJ: Princeton University Press, 2001.

Corn, Wanda. *The Great American Thing: Modern Art and National Identity, 1915–1935*. Berkeley: University of California Press, 1999.

Craven, Wayne. *American Art: History and Culture*. New York: Harry N. Abrams, Inc., 1994.

Cropsey, Jasper F. "Up Among the Clouds." *The Crayon* 2, no. 6 (August 8, 1855): 79.

Davidson, Abraham A. *Early American Modernist Painting, 1910–1935*. New York: Harper and Row, 1981.

Dryfhout, John. In *Augustus Saint-Gaudens, 1848–1907: A Master of American Sculpture*. Toulouse, France: Musée des Augustins, 1999.

Durand, Asher B. "Letters on Landscape Painting." Letters 1–4, nos. 5–9. *The Crayon*, vols. 1–2 (January 3–July 4, 1855).

Eddy, Arthur Jerome. *Cubists and Post Impressionism*. Chicago: A. C. McClurg, 1914.

"Editor's Easy Chair." *Harper's New Monthly Magazine* 10, no. 56 (January 1855): 263–74.

Faxon, Susan, Avis Berman, and Jock Reynolds. *Addison Gallery of American Art: 65 Years—A Selective Catalogue*. Andover, MA: Addison Gallery of American Art, 1996.

Faxon, Susan. *Winslow Homer at the Addison*. Andover, MA: Addison Gallery of American Art, 1990.

Ferber, Linda S., and William H. Gerdts. *The New Path: Ruskin and the American Pre-Raphaelites*. Brooklyn, NY: The Brooklyn Museum, 1985.

Foshay, Ella M., and Barbara Finney. *Jasper F. Cropsey: Artist and Architect*. New York: The New-York Historical Society, 1987.

Gage, John. *Color and Culture/Practice and Meaning from Antiquity to Abstraction*. Berkeley and Los Angeles: University of California Press, 1993.

Greenberg, Clement. "The Late Thirties in New York." In *Art and Culture, Selected Essays*. Boston: Beacon Press, 1961. First published 1957 and 1960.

Greenough, Sarah. *Modern Art and America: Alfred Stieglitz and His New York Galleries*. Washington, D.C.: National Gallery of Art, 2000.

Griffin, Randall C. *Homer, Eakins, & Anshutz: The Search for American Identity in the Gilded Age*. University Park: The Pennsylvania State University Press, 2004.

Hamilton, George Heard. *Painting and Sculpture in Europe, 1880–1940*. 6th ed. New Haven, CT: Yale University Press, 1993.

Harris, Neil. *The Artist in American Society: The Formative Years, 1790–1860*. New York: George Braziller, 1966.

Henderson, Linda Dalrymple. *Duchamp in Context: Science and Technology in "The Large Glass" and Related Works*. Princeton, NJ: Princeton University Press, 1998.

Henri, Robert. *The Art Spirit*. New York: Harper and Row, 1984. First published 1923.

Hills, Patricia. *John Singer Sargent*. New York: Whitney Museum of American Art, 1986.

Homer, William Innes. *Alfred Stieglitz and the American Avant-Garde*. Boston, MA: NY Graphic Society, 1977.

——. *Robert Henri and His Circle*. Ithaca, NY: Cornell University Press, 1999.

Homer, William Innes, ed. *Avant-Garde: Painting & Sculpture in America, 1910–1925*. Wilmington: Delaware Art Museum, 1975.

Hoppin, Martha J. "The Sources and Development of William Morris Hunt's Painting." In *William Morris Hunt: A Memorial Exhibition*. Boston: Museum of Fine Arts, 1979.

Inness, George, Jr. *Life, Art and Letters of George Inness*. New York: The Century Co., 1917.

James, Henry, Jr. "On Some Pictures Lately Exhibited." *The Galaxy* 20 (July 1875): 93–94.

Johns, Elizabeth. *Thomas Eakins: The Heroism of Modern Life*. Princeton, NJ: Princeton University Press, 1983.

——. *Winslow Homer: The Nature of Observation*. Berkeley: University of California Press, 2002.

Johnson, Ellen, ed. *American Artists on Art from 1940 to 1960*. New York: Harper and Row, 1982.

Johnston, Sona. *In Monet's Light: Theodore Robinson at Giverny*. Baltimore: The Baltimore Museum of Art, 2004.

Kelder, Diane, ed. *Stuart Davis*. New York: Praeger, 1971.

Lawall, David B. *A. B. Durand, 1796–1886*. Montclair, NJ: Montclair Art Museum, 1971.

——. *Asher B. Durand: A Documentary Catalogue of the Narrative and Landscape Paintings*. New York: Garland Publishing, 1978.

McCoubrey, John W., ed. *American Art: 1700–1960, Sources and Documents*. Englewood Cliffs, NJ: Prentice-Hall, Inc., 1965.

McShine, Kynaston, ed. *The Natural Paradise: Painting in America, 1800–1950*. New York: The Museum of Modern Art, 1976.

Miller, Perry. *Nature's Nation*. Cambridge, MA: The Belknap Press of Harvard University Press, 1967.

Milroy, Elizabeth. *Painters of a New Century: The Eight and American Art*. Milwaukee, WI: Milwaukee Art Museum, 1991.

Murray, Richard N. "Painting and Sculpture." In *The American Renaissance, 1876–1917*. Brooklyn: The Brooklyn Museum, 1979.

Noble, Louis L. *The Course of Empire: Voyage of Life, and Other Pictures of Thomas Cole*. New York: Cornish, Lamport & Company, 1853.

Novak, Barbara. *Nature and Culture: American Landscape and Painting, 1825–1875*. New York: Oxford University Press, 1980.

"A Painter on Painting." *Harper's New Monthly Magazine* 56 (February 1878): 458–61.

Pohl, Frances K. *Framing America: A Social History of American Art*. New York: Thames and Hudson, 2002.

Polcari, Stephen. *Abstract Expressionism and the Modern Experience*. New York: Cambridge University Press, 1991.

Porter, Fairfield. "Art and Knowledge." In *Art in Its Own Terms, Selected Criticism, 1935–1975*, edited by Rackstraw Downes. New York: Taplinger Press, 1979. First published 1966.

Quick, Michael. "Technique and Theory: The Evolution of George Bellows's Painting Style." In T*he Paintings of George Bellows*. Fort Worth, TX: Amon Carter Museum, 1992.

Reinhardt, Ad. "Art-as-Art," *Art International* 6, no. 10 (December 20, 1962). Reprinted in *American Artists on Art from 1940 to 1960*, edited by Ellen Johnson. New York: Harper and Row, 1982.

"The Relation of Painting to Architecture: An Interview with George Bellows, N. A., in Which Certain Characteristics of the Truly Original Artist Are Shown to Have a Vital Relation to the Architect and His Profession. *American Architect* 118 (December 29, 1920): 848.

Rose, Barbara. *Readings in American Art since 1900: A Documentary Survey*. New York: Praeger, 1968.

Rothko, Mark, and Adolph Gottlieb. Letter to the editor, *New York Times*. Quoted in Edward Alden Jewell, "'Globalism' Pops into View." *The New York Times* (Sunday, June 13, 1943). Reprinted in Johnson, *American Artists on Art*, pp. 13–14.

Saint-Gaudens, Homer, ed. *The Reminiscences of Augustus Saint-Gaudens*. Vol. 2. New York: The Century Co., 1908.

Sandler, Irving. *The Triumph of American Painting: A History of Abstract Expressionism*. New York: Praeger, 1970.

Sheldon, George. "A New Departure in American Art." *Harper's New Monthly Magazine* 56 (April 1878): 764–78.

Smith, David. "Second Thoughts on Sculpture." In *Readings in American Art since 1940*, by Barbara Rose. New York: Praeger, 1968. First published spring 1954 by College Art Journal.

Stavitsky, Gail. *Precisionism in America, 1915–1941: Reordering Reality*. New York: Harry N. Abrams, 1994.

Stein, Roger B. *John Ruskin and Aesthetic Thought in America, 1840–1900*. Cambridge, MA: Harvard University Press, 1967.

Stella, Frank. *Working Space*. Cambridge, MA: Harvard University Press, 1986.

Tuchman, Maurice, ed. *The Spiritual in Art: Abstract Painting, 1890–1985*. New York: Abbeville Press, 1986.

Weinberg, H. Barbara. "Cosmopolitan Attitudes: The Coming of Age of American Art." In *Paris 1889: American Artists at the Universal Exposition*. Philadelphia: Pennsylvania Academy of the Fine Arts, 1989.

Weinberg, H. Barbara, Doreen Bolger, and David Park Curry. *American Impressionism and Realism: The Painting of Modern Life, 1885–1915*. New York: The Metropolitan Museum of Art, 1994.

Whittredge, Worthington. "The Autobiography of Worthington Whittredge," edited by John I. Baur. *Brooklyn Museum Journal* 1 (1942).

Wilmerding, John, ed. *American Light: The Luminist Movement, 1850–1875*. Washington, D.C.: National Gallery of Art, 1989.

Winslow Homer at the Addison. Andover, MA: Phillips Academy, Addison Gallery of American Art, 1990.

Wright, Willard Huntington. *Modern Painting: Its Tendency and Meaning*. New York: Dodd, Mead and Company, 1915.

Zilczer, Judith. "The Aesthetic Struggle in America, 1913–1918: Abstract Art and Theory in the Stieglitz Circle." Thesis, University of Delaware, 1975.

Zurier, Rebecca, Robert W. Snyder, and Virginia M. Mecklenburg. *Metropolitan Lives: The Ashcan Artists and Their New York*. Washington, D.C., and New York: National Museum of American Art in association with W.W. Norton & Company, 1995.

Index